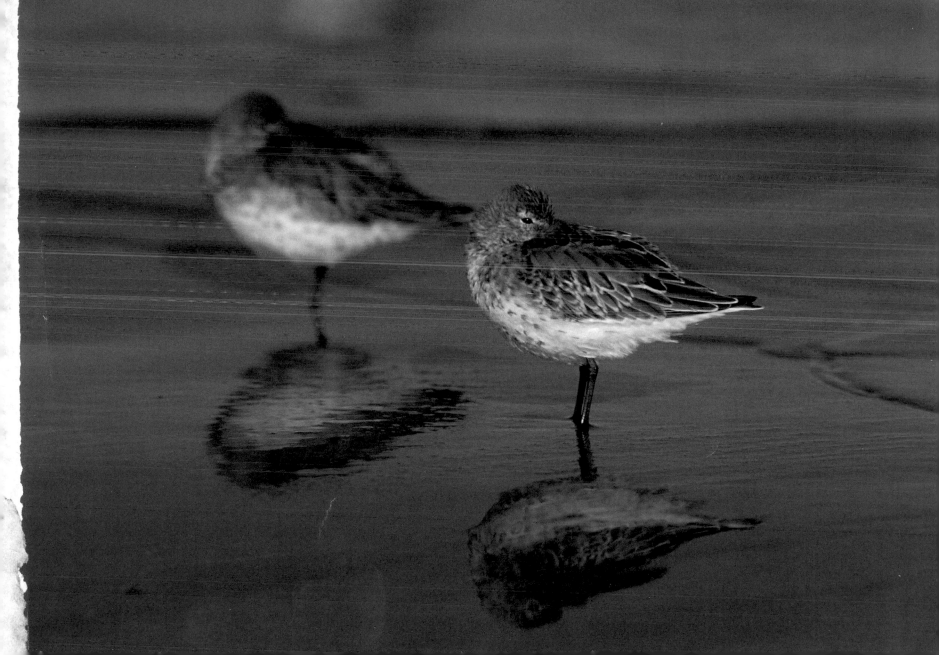

WILD ISLAND
PRINCE EDWARD ISLAND'S HIDDEN WILDERNESS

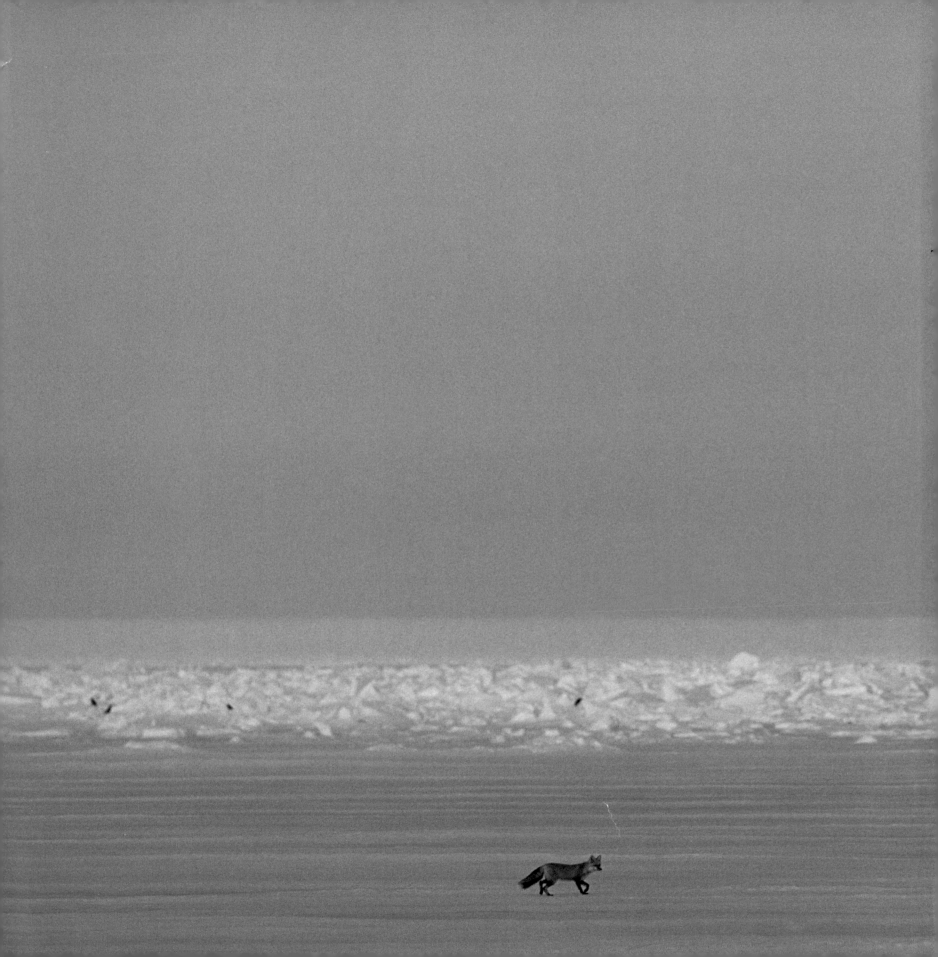

WILD ISLAND
PRINCE EDWARD ISLAND'S HIDDEN WILDERNESS

JOHN SYLVESTER

ACORN PRESS
CHARLOTTETOWN

Wild Island: Prince Prince Edward Island's Hidden Wilderness
ISBN 978-1-894838-43-6

Design by Matthew MacKay
Printed in Canada by Friesens

The publisher acknowledges the support of the Government of Canada through the Book Publishing Industry Development Program (BPIDP) of the Department of Canadian Heritage for our publishing activities. We also acknowledge the support of the Canada Council for the Arts and the Prince Edward Island Department of Communities, Cultural Affairs, and Labour for our publishing program.

The author gives special thanks to Jackie Waddell and the staff of the Island Nature Trust, Diane Griffin and Crystal Folkins of the Nature Conservancy of Canada, Kate MacQuarrie, and Dr. Donna Giberson, Professor of Biology at the University of Prince Edward Island.

Part of the royalties are being donated to The Island Nature Trust (islandnaturetrust.ca), a conservation group that for thirty years has worked tirelessly to protect the Island's remaining natural communities.

Library and Archives Canada Cataloguing in Publication

Sylvester, John
 Wild island : Prince Edward Island's hidden
wilderness / John Sylvester.

ISBN 978-1-894838-43-6

 1. Natural areas—Prince Edward Island—Pictorial works.
2. Landscape—Prince Edward Island—Pictorial works. 3.
Prince Edward Island—Pictorial works. I. Title.

QH77.C3S95 2009 917.170022'2 C2009-902199-4

P.O. Box 22024
Charlottetown, Prince Edward Island
C1A 9J2

acornpresscanada.com
johnsylvester.com

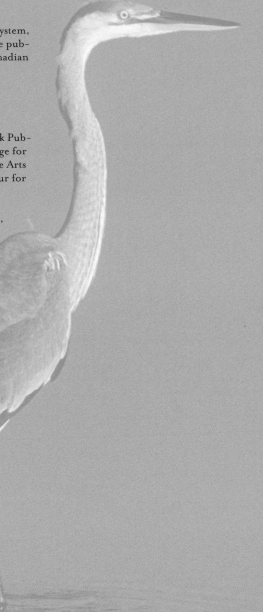

FOR DIANNE,
AND TO THE MEMORY
OF MY FATHER,
GEORGE SYLVESTER,
FOR SHARING HIS LOVE
AND APPRECIATION
OF THE NATURAL WORLD.

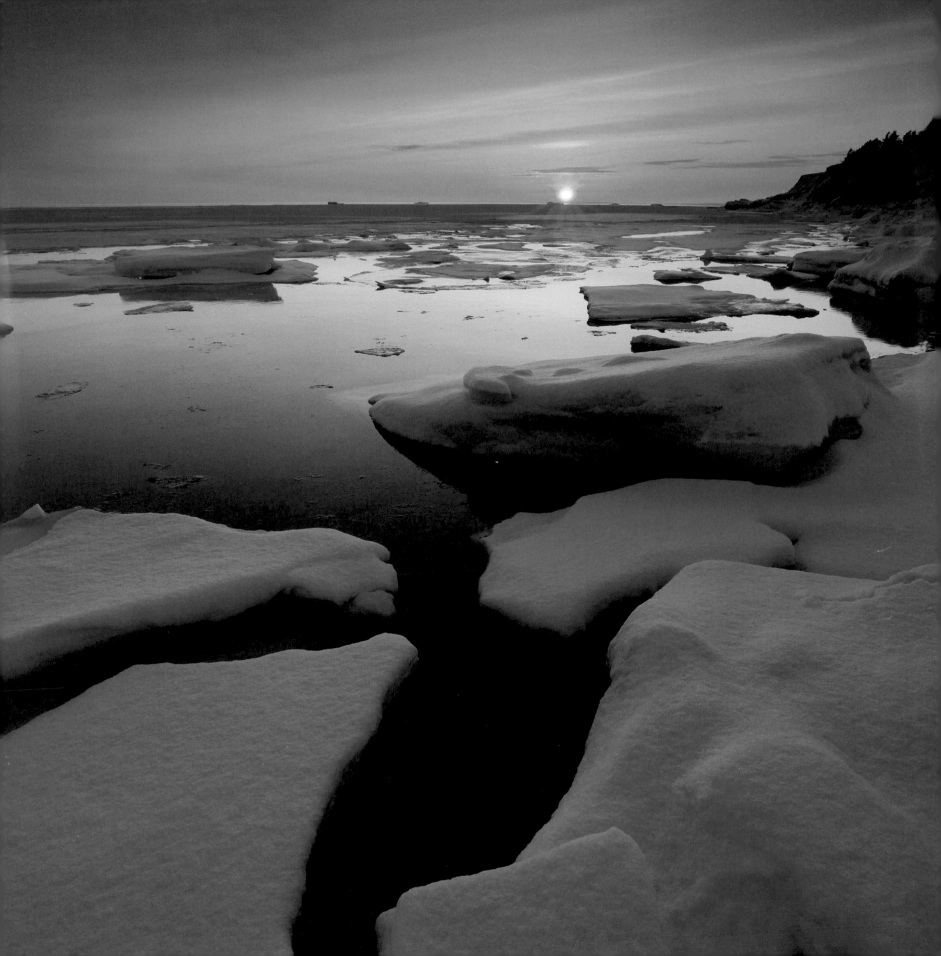

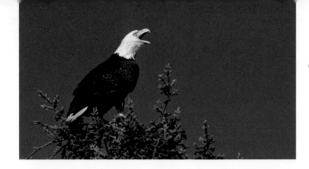

"Wilderness is not a luxury, but a necessity of the human spirit."
—Edward Abbey

PREFACE

"There are some who can live without wild things, and some who cannot," writes Aldo Leopold in the introduction to his 1948 classic of the conservation movement, *A Sand County Almanac*. Like Leopold, I fall firmly into the latter category. Whether it is a long walk down a deserted beach, the discovery of spring wildflowers on the forest floor, or the sight of a bald eagle soaring above my canoe, it is the experience of wild things that brings peace, wonder, and inspiration to both my work and my life.

The challenge in doing this book is that so many of Prince Edward Island's "wild things" have disappeared. It's a bit like assembling a puzzle with ninety per cent of the pieces missing. After all, the Acadian Forest that once covered almost the entire Island is gone, replaced by a patchwork agricultural landscape of fields and mixed woodland that is a mere shadow of the ancient forest it replaced. "Wilderness" does not exist here the same way it does in the rest of Canada where there are still large tracts of unspoiled land. The Island's natural areas are small scattered fragments, mere remnants of the wild landscape that existed here more than 300 years ago, before the arrival of European settlers. And yet many of these fragments — those that were considered of little economic importance such as the sand dunes, cliffs, wetlands, and bogs — have remained essentially the same as they were before the settlers arrived. Fortunately, these are also the Island's most unique natural features.

Through my photography, I have attempted to gather together these fragments and present a picture of Prince Edward Island as I imagine it might have appeared before permanent settlement. This is not a guidebook to natural areas, but a portrait of the diversity and beauty of what remains. The Island Nature Trust, a conservation group that for thirty years has worked tirelessly to protect the Island's remaining natural communities, has identified nine areas — sand dunes, offshore islands, woodlands, riparian zones, salt-marshes, natural ponds, bogs, cliffs, and marine areas — which I have used as my own rough guide. Some of these ecosystems — sand dunes, salt marshes, natural ponds — are also protected within the borders of Prince Edward Island National Park. More recently, the Nature Conservancy of Canada has stepped into the local picture to protect significant natural areas such as Boughton Island, the province's largest uninhabited offshore island.

A few days before I sat down to write these words, my wife, son, and I canoed the Clyde River near our home. Putting in at New Glasgow, we paddled upstream through a small wildlife sanctuary towards the river's source. As the channel narrowed and the treetops closed in above us, we spotted five bald eagles roosting in the branches overhead. The eagles glided ahead of us from branch to branch as we made our way upriver. It was a wonderful moment and the expression of awe on our son's face encouraged my belief that a life touched by "wild things" is richer for it.

The images on these pages were made during many such moments. I hope this book will inspire readers to explore Prince Edward Island's natural areas for themselves and that they will be further inspired to support the cause of natural areas conservation. We need to save and protect the "wild things" that are left.

Sunrise at ice edge, Prince Edward Island National Park

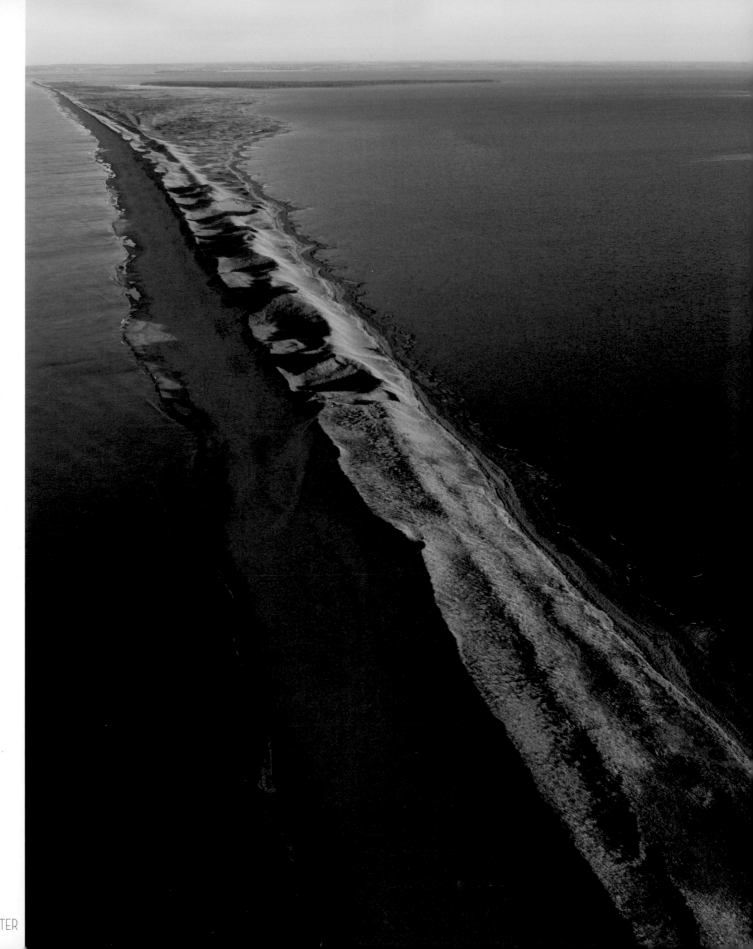

INTRODUCTION

Twenty-five years ago, with camera balanced precariously in hand, I crawled on my stomach along a beach on Prince Edward Island's north shore. After several uncomfortable hours inching forward I finally came face to face with a diminutive shorebird, the Piping Plover, incubating a clutch of four eggs in a nest scraped out of the sand. To my surprise and delight the bird stubbornly remained on its nest, allowing me to continue photographing until the evening light faded. It was a rare moment I shall never forget.

This face-to-face encounter happened while working as a photographer with Prince Edward Island National Park. It was a wonderful summer job that not only gave me a chance to become acquainted with small shorebirds, but also introduced me to the distinctive natural areas of this island province.

Photographing the Piping Plover was a good place to start, as this endangered species embodies the challenge of wildlife and natural area protection in Prince Edward Island. Typically, the tiny shorebird nests on beaches between the high-tide mark and the base of the dunes. But this is also the preferred habitat for close to a million human visitors who flock to the Park's beaches during the six-week summer tourist season. The challenge is to protect the plovers while allowing humans to enjoy the Park. It is not an easy task. Although the eggs in the nest I photographed eventually hatched, and the chicks survived to fledge successfully, many do not. Spring storms wash out nests, and predators such as gulls, crows, ravens, foxes, and marsh hawks take their toll. Add human disturbance to the equation and the balance is easily upset.

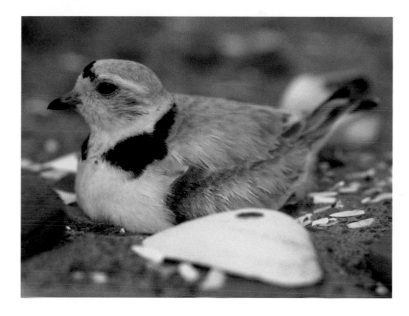

It can be argued that Prince Edward Island's ecological balance was upset long ago. Today's distinctive patchwork landscape of farm fields and woodland is a far cry from the forested landscape that greeted the first explorers. When Jacques Cartier sailed along the Island's north shore in the summer of 1534 he described it as "the fairest land 'tis possible to see," remarking on the dense forest, extensive sand dunes, and shallow bays. He also sighted several First Nations people in their canoes.

Aboriginal people had, of course, crossed from the mainland to the Island for centuries before Europeans arrived. Archaeological evidence shows human presence dating back at least 10,000 years. The Island was primarily a summer place for hunting, fishing, gathering berries, and harvesting the plentiful shellfish in the shallow bays and estuaries. But these activities had very little impact on the natural environment.

Piping Plover
Hog Island

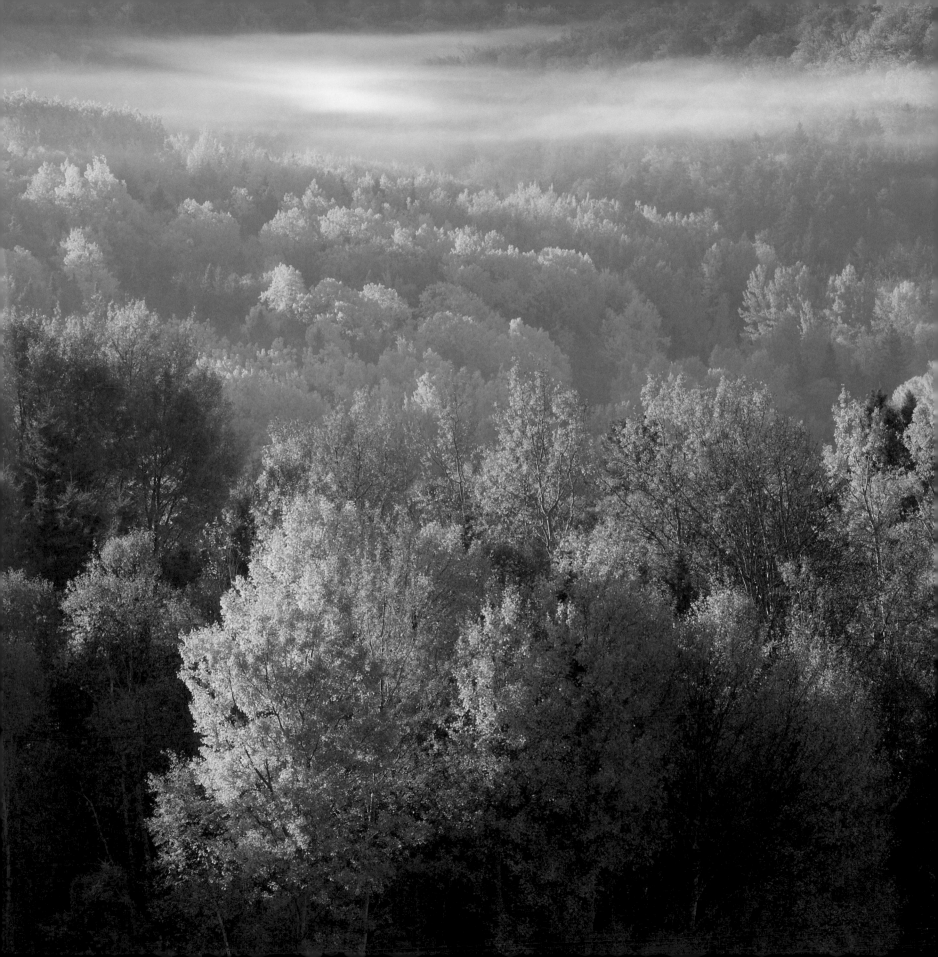

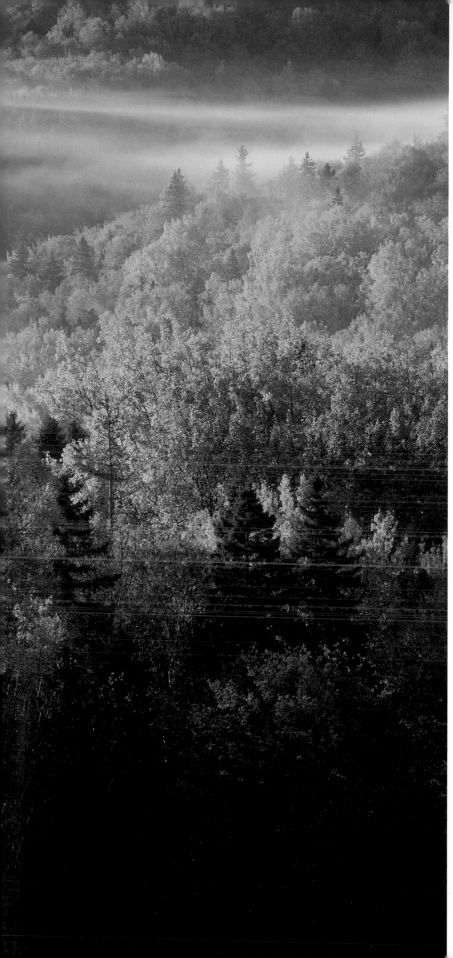

As a result, when the first French settlers arrived in the early 1700s, they encountered a pristine forested landscape. Hardwoods such as American beech, sugar maple, yellow birch, and red oak covered the upland areas, with conifers such as white pine, fir, spruce, hemlock, cedar, and tamarack populating the lowlands. Moose, bear, woodland caribou, elk, and lynx, as well as many smaller mammals, inhabited the forest; and walrus, also known as the Seacow, hauled themselves out on beaches and sand bars. Today, the only reminders of their presence are the place names of Seacow Pond and Seacow Head. Huge flocks of ducks and geese used the sheltered bays and ponds as resting places on their spring and fall migrations to and from their northern nesting grounds. And years before permanent settlers arrived, Basque fishermen exploited the abundant fish and shellfish in the waters surrounding the Island.

With the arrival of the settlers, forest destruction began in earnest. First the French, and later the British, cut, burned, and cleared the trees until, by the late 1800s, the beautiful Acadian forest that Cartier described 250 years earlier had all but disappeared. Along with it went the large mammals. The last black bear is believed to have been killed in the early 1900s at about the same time land used for agriculture peaked at close to seventy per cent of the Island's territory. Some of that land was eventually abandoned in the mid-1900s and left to grow up into a different type of forest, mainly white spruce woodland. Today, slightly less than fifty per cent of the Island is tree-covered. Smaller mammals capable of surviving in the margins of a pastoral landscape continue to do so, such as the red fox, beaver, and muskrat; while waterfowl, albeit in fewer numbers, continue their migration stopovers on the Island's waterways.

Bonshaw Hills

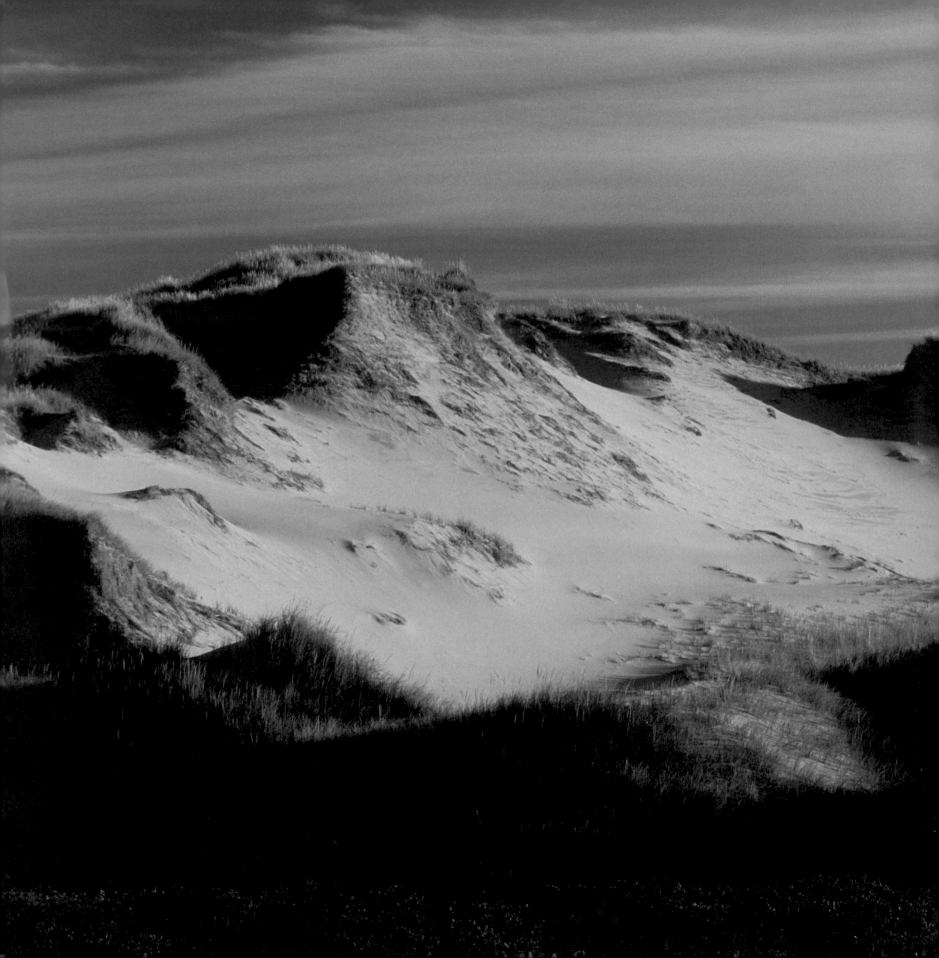

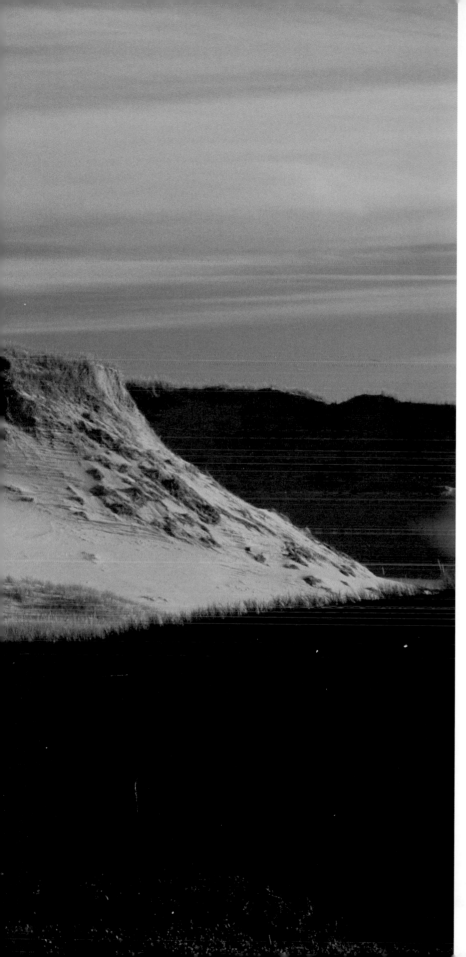

There have also been new arrivals, both plant and animal. Prince Edward Island is famous for the colourful lupin that flourishes in roadside ditches every June. It is not a native species, but an exotic introduced from Europe. In fact, about a third of the Island's "wild" flora comes from "away."

Skunk and raccoon were introduced by optimistic fur farmers hoping to cash in on the fox fur boom of the 1920s by expanding into other fur-bearing species. Their optimism was not to be matched by the realities of the marketplace, however, so they released the animals into the countryside, where, in the absence of predators, they have flourished. The pungent odour of roadkill skunk on Island highways is a perpetual reminder of their folly.

A relatively new arrival to Prince Edward Island is the coyote. Crossing the ice of Northumberland Strait from the mainland sometime in the early 1980s, this wily and adaptable critter has flourished in its new home. But their arrival has had an impact on the Red Fox population because they will not tolerate foxes within their range. Foxes have had to find new territory, often much closer to humans, which explains the frequent sightings around houses, farm buildings, and even on crowded beaches where they've been known to mooch for food from well-meaning, but ill-informed, tourists. Sadly, relying on handouts can lead to their deaths once their food source dries up when the tourists go home, and they face a long difficult winter lacking the necessary hunting skills to fend for themselves.

During the settlement years, the changes to Prince Edward Island's natural environment were profound. And while I lament the loss of so much wilderness, I'm thankful that during the Island's transformation from forest to farmland, some of its most significant natural features were spared. The Island's iconic and extensive sand dune systems, barrier islands, and wetlands are unparalleled anywhere in North America.

Greenwich, parabolic dune

Today, a portion of these ecosystems are protected within the borders of Prince Edward Island National Park. Created in 1937, one of Canada's smallest national parks encompasses a portion of the Maritime Plain Natural Region — twenty-two square kilometres of dunes, beaches, barrier islands, sand spits, and wetlands extending in a narrow forty-kilometre strip along the province's north shore.

In 1998, the magnificent Greenwich sand dunes were added to the Park after a twenty-year struggle by conservationists to protect the area from development. Isolated at the tip of the Greenwich Peninsula in eastern Prince Edward Island, this remarkable area had already gained recognition from the United Nations International Biological Program and the World Wildlife Endangered Species Program before Parks Canada acquired the property. Its most significant feature is the rare parabolic dunes, huge crescent-shaped sand hills formed by the prevailing onshore winds. Migrating inland at a rate of two to four metres annually, they leave in their wake a series of low ridges called counter ridges, or *Gegenwalle*. These sand ridges are colonized by marram grass which anchors the sand with its extensive root system and allows other species such as wild rose, bayberry, goldenrod, and beech pea to take root. Greenwich is the only site in North America where *Gegenwalle* is found.

The migrating dunes are also slowly burying the nearby forest, and, as they move, the previously buried trees become exposed. The remains of the bleached and bare-limbed trees are known as an exhumed skeleton forest.

Behind the sand dunes at Greenwich, and all along the Island's coast, both within park boundaries and beyond, are freshwater ponds called barrier or barachois ponds. The ponds are formed when wind and ocean currents cause migrating dunes to close off the entrance to a bay. Cut off from the ocean's tidal influence, the bay eventually desalinates to form a freshwater pond. The dense growth of reeds and bulrushes along their shores provides important habitat for muskrat, beaver, waterfowl, and shorebirds.

In some cases the formation of a barachois pond is a relatively recent event. Long Pond, near Dalvay, was open to the Gulf of St. Lawrence in the early 1700s. It was home to an Acadian fishing community before shifting sands closed off the narrow entrance to the bay, blocking their access to the sea and forcing the community's abandonment. As it became landlocked, Long Pond slowly transformed from a saltwater bay into a freshwater pond.

With its long undulating coastline and shallow bays and estuaries, Prince Edward Island is blessed with an abundance of saltwater marshes. Although you wouldn't guess by looking at them, saltwater marshes are some of the most productive ecosystems on the planet, comparable to the rain forests. The foundation plant in a saltwater marsh is called cordgrass, of which there are three types: Freshwater, or Rough Cordgrass, occupies the upper reaches of the salt marsh; Saltwater Cordgrass is found in the middle zone; while Saltmeadow Cordgrass occupies the lower reaches of the marsh, nearest the water. It sends down underground stems, or rhizomes, forming a dense matt in the intertidal zone. This slows down tidal flow causing sediment accumulation and the buildup of organic material. Tidal action flushes organic sediments from the salt marsh into the surrounding bay, where it is utilized by fish and other aquatic animals, which explains the Island's productive aquaculture fishery in oysters and mussels. Saltwater marshes are also important feeding grounds for birds such as the Great Blue Heron, waterfowl, and shorebirds.

Bogs are a completely different kind of wetland. A walk across a bog is a bit like walking on a giant sponge: rubber boots and good balance are mandatory. The Island's bogs were formed thousands of years ago when receding glaciers left depressions in the land from which water couldn't drain. Slowly the depressions filled in with vegetation. Sphagnum moss is the predominant plant species in this oxygen-deprived and acidic environment. As moss decays it forms peat, allowing other hardy plants to take root, including the unusual "insect-eating" Pitcher Plant and Round Leafed Sundew. The Pitcher Plant catches rainwater in its vase-shaped leaves, trapping insects for digestion by the plant. The Sundew snares tiny flying insects in the sticky secretions at the end of its leaves, which then wrap around the insect, digesting it.

Almost one hundred named rivers crisscross a Prince Edward Island map, but to call them rivers is an exaggeration, as most Island waterways are really tidal inlets or estuaries. You must paddle your canoe a fair distance inland to escape the tide's ebb and flow, and to taste fresh water. By then you will be in what could be more correctly called a stream, if you're lucky to have enough water to float a canoe. But it's a journey worth taking and one I often make on the rivers near my home. Heading upstream from the brackish waters of the estuary, the shoreline vegetation changes with the salt content of the water. Cordgrass eventually gives way to bulrushes. In early May, Marsh Marigolds — one of the first flowers of spring — bloom profusely along river edges, offering a burst of colour amongst the matted grey remains of bulrushes. Bald eagles and osprey are a regular sight. Bald eagles are early nesters, beginning in March, often reusing their nest from the previous year. By the time the ice breaks up, and I can get my canoe in the water, there are already a couple of scruffy young eaglets perched in their aerie, while their parents circle warily over my drifting canoe.

In the waters surrounding Prince Edward Island, there are about twenty offshore islands varying in size from just a few acres to several hundred. Some of the larger ones, such as Boughton Island in Cardigan Bay and St. Peter's Island in Hillsborough Bay, were once cleared for agriculture but later abandoned to grow up into spruce woodland. Most of the smaller islands were never inhabited. Hog Island is one of a series of spectacular, uninhabited barrier islands, or offshore sand dunes, extending for almost forty kilometres across the mouth of Malpeque Bay and along the Island's northwest coast to Cascumpec Bay.

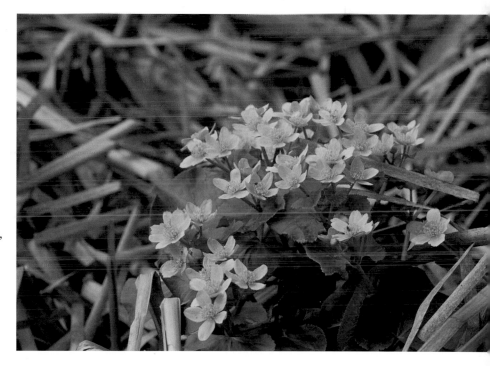

Marsh Marigold blossom

The relative isolation of the offshore islands makes them important sites for colonial nesting birds such as great blue herons, cormorants, gulls, and terns. Harbour seals sun themselves on secluded beaches, which are also important nesting sites for Piping Plovers. Saltwater marshes associated with offshore islands are important staging areas for migrating waterfowl.

Sharply delineating ocean and land are the Island's characteristic red sandstone cliffs, which often appear to be sandwiched precariously between farm fields (or coastal cottage development) on the one side and pounding waves and scouring sea ice on the other. But it's here that the bedrock underlying all of Prince Edward Island reveals itself. Three hundred million years ago, rivers flowing out of highlands in what is now western Nova Scotia and parts of New Brunswick, Newfoundland, and Quebec flowed into an immense lowland that is now the Gulf of St. Lawrence. Over the course of seventy-five million years, layers of sediment were deposited to form today's bedrock. Large amounts of iron in those sediments eventually oxidized, or rusted, giving the rock its distinctive red appearance. The sediment layers are easily visible on any coastal cliff. Pick up a piece of sandstone, and you'll find it so soft you can break it in your hands — which is why the coastline is so vulnerable to erosion, losing up to a metre a year in some places.

The cliffs are home to Swallows, Black Guillimots, Herring Gulls, and Black-Backed Gulls, with cormorants the most prolific of cliff-dwellers. One of the best-known cormorant colonies, where two species, Double Crested and the less common Great Cormorant, are found, is located on the Island's highest coastal cliffs at Cape Tryon.

The only designated Marine Protected Area in Prince Edward Island is a saltwater lagoon behind Basin Head Beach, on the Island's northeastern coast. It gained this designation in October 2005, primarily to protect a rare species of Irish Moss, which is actually a type of seaweed (*Chondrus crispus*). Irish moss is harvested in Prince Edward Island for its carageenan, a thickener used in many household products such as toothpaste and ice cream.

Although about fifty per cent of Prince Edward Island is now tree-covered, only a tiny fraction of that would resemble the Acadian forest that Jacques Cartier observed almost five hundred years ago. Scattered remnants of Acadian forest can be found in private wood lots, provincial crown land, and properties protected by the Island Nature Trust. The Townshend Woodlot, located just north of the town of Souris in eastern Prince Edward Island, is one of the best hardwood groves in the province. Walking amongst its towering sugar maples and beech trees, it is easy to imagine what the Island must have looked like centuries ago before settlers arrived. In the springtime the forest floor is sprinkled with wildflowers such as bunchberry, violets, painted trilliums, and the Pink Lady's Slipper, the province's floral emblem. In autumn the forest canopy is a blaze of orange, yellows, and reds. On a recent visit I walked deep into the woods and stood below the tallest trees... and listened. I could not hear a single sound created by humans — a rare occurrence in this densely populated province.

The entire acreage of all Prince Edward Island's protected natural areas is less than three per cent of the total land mass. It is not nearly enough. In 1989, the World Wildlife Fund challenged jurisdictions throughout the world to protect twelve per cent of their land mass. In Canada only two provinces, British Columbia and Alberta, and one territory, Yukon, have achieved the twelve per cent goal. When it comes to protecting natural areas, Prince Edward Island ranks at the bottom, alongside New Brunswick, among the provinces and territories. The province's tiny size, population density — it is the most densely populated

province in Canada — and settlement history have conspired against natural areas protection. With ninety per cent of land in private hands, and only ten per cent publicly owned, there are limited public means by which to protect natural areas. And with a history of resource-exploitive industries — fishing, farming, and forestry — land has traditionally been valued for its development potential rather than its intrinsic nature.

In 1991, Prince Edward Island set a reasonable goal of protecting seven per cent of its land mass. Little progress has been made.

During the past ten years more than two dozen incidents of fish kills from pesticide run-off in Island waterways have been reported. These have been largely due to increased potato acreages, a crop that requires large applications of pesticides and which leaves land vulnerable to soil erosion. Soil and pesticide run off into Island waterways is a serious threat to the aquatic environment, not only affecting fish, but also frogs, shellfish, shorebirds, and larger species, such as bald eagles that ingest the deadly chemicals when they feed on dead fish. Sediment buildup on stream beds further damages spawning grounds for salmon and trout. Legislation requiring three-year crop rotation on potato land and buffer zones along waterways has had some effect, but the North American appetite for French fries will keep the pressure on Island farmland, and, in turn, on the health of the province's soil and water and the living things that depend on it.

On yet another front, escalating demand for coastal properties is threatening the Island's fragile coastline. Prince Edward Island National Park has the dubious distinction of twice being named the most endangered national park in Canada, "...due to a range of cottage and resort development surrounding its borders." Outside Park borders, coastal development has run amok, with no controls whatsoever for cottage and resort development. "Endangered" as it may be, we can be thankful for the National Park's existence. At least some of the Island's exquisite coastal natural areas and wildlife inhabitants have a measure of protection within its borders.

Despite continuing environmental problems and government indifference, there have also been some significant successes in protecting the Island's natural areas — most significantly with the protection of the Greenwich sand dunes. Another success story is the steadily expanding Bald Eagle population. After years of persecution and widespread reproductive failure during the 1940s and '50s due to the use of the pesticide DDT, the number of Bald Eagles is on the increase. In the early 1980s, there was only one known Bald Eagle nest in the province; today there are at least seventy-five. I take great pleasure in the almost daily sightings of eagles patrolling the valley below my rural home.

Prince Edward Island's remaining natural areas are worth saving and protecting. It is my sincerest hope that this book will contribute to both awareness and appreciation of our natural areas. If wild nature can find a place in our consciousness, then there is hope, and action is possible. We owe it to future generations to leave a portion of this Island undisturbed so the eagle may continue to soar, the fox to roam, and a tiny endangered shorebird, the Piping Plover, to survive.

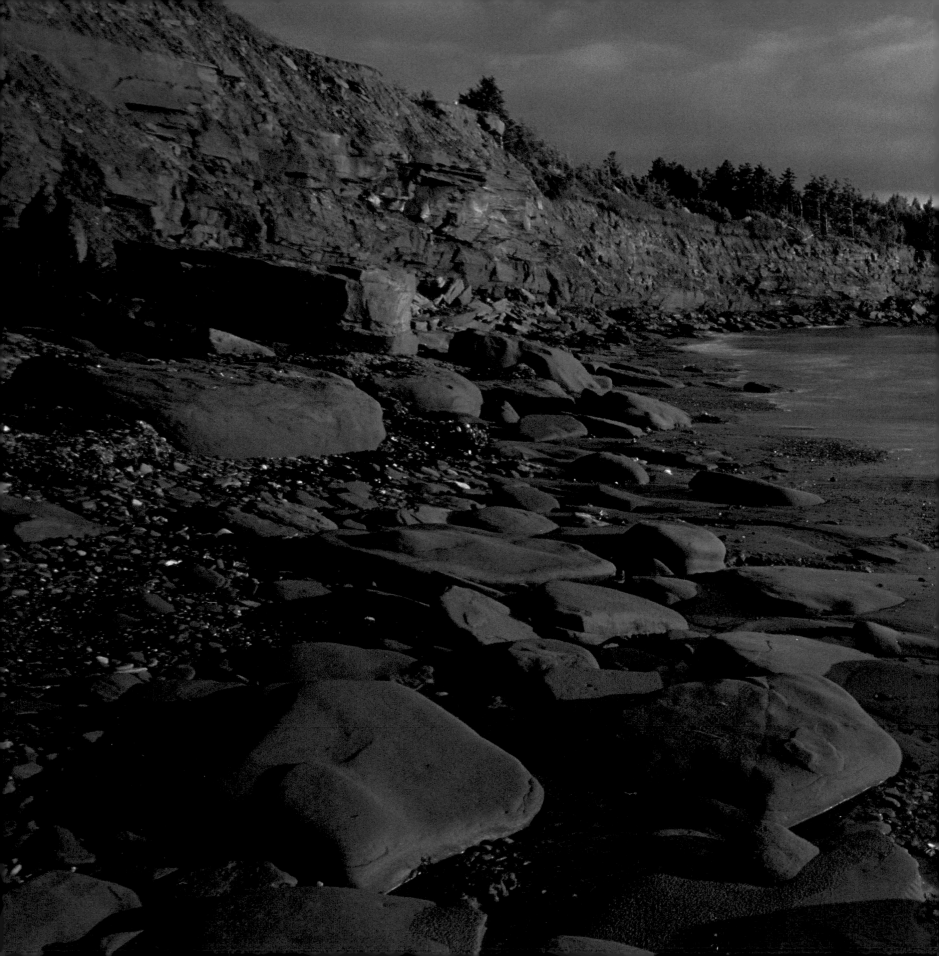

COAST

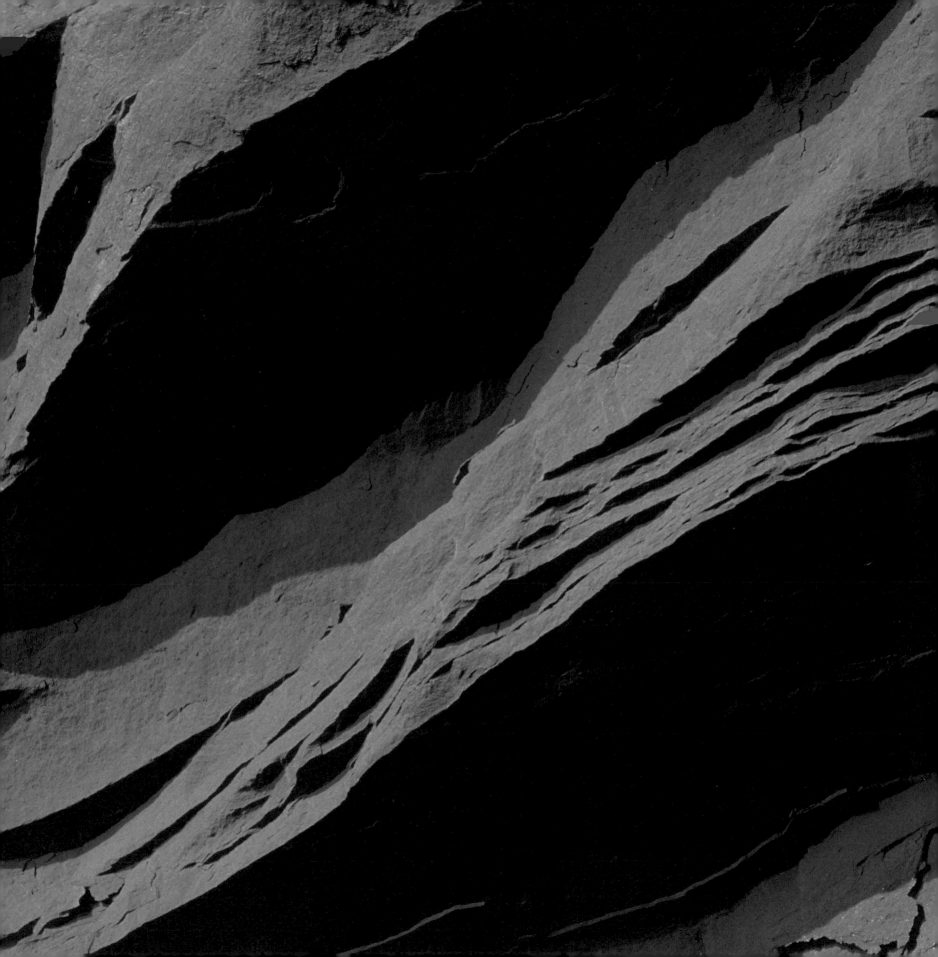

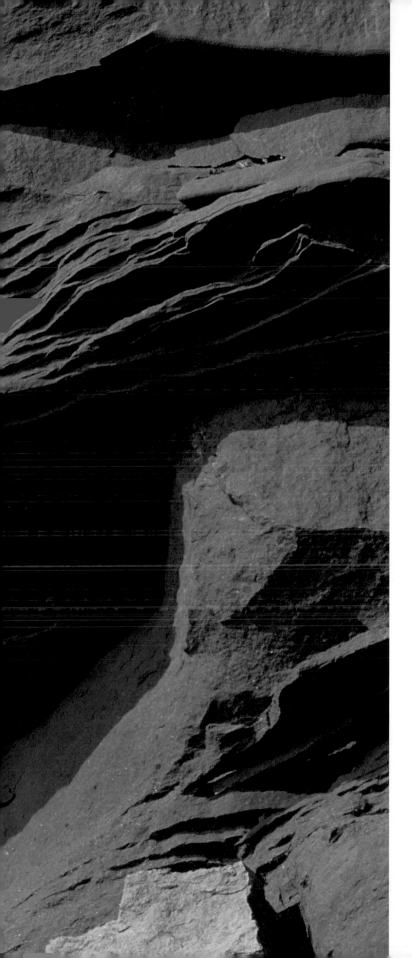

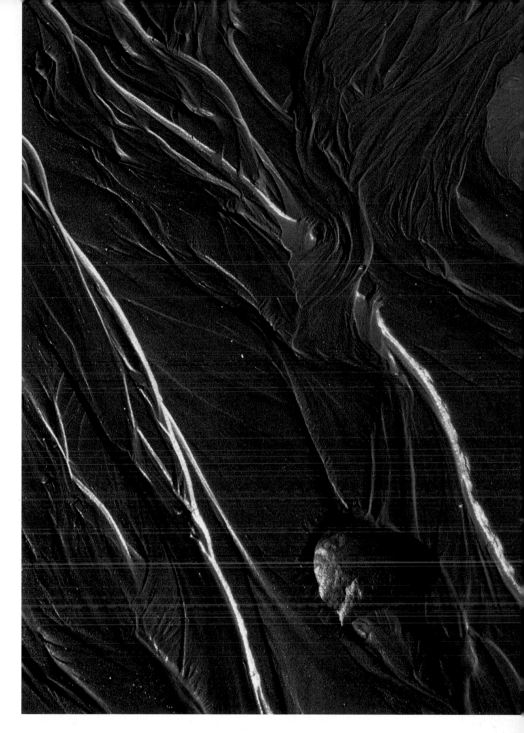

Previous pages: Cape Turner, Prince Edward Island National Park

The Island's distinctive sedimentary bedrock was formed when ancient rivers laid down sediments in what is now the Gulf of St. Lawrence. The high iron content in these sediments eventually oxidized, or rusted, giving the rock its characteristic red colour. There are actually six different types of bedrock underlying the Island, five sedimentary and one small igneous outcropping, on George Island, in Malpeque Bay. Sandstone is by far the most common type. It is soft, easily broken, and prone to erosion. Wave and ice action remove up to a metre of coastline annually in some areas of the Island. But what is lost in one area is gained in another, as eroded rocks are ground into sand by the sea and deposited on beaches and barrier islands.

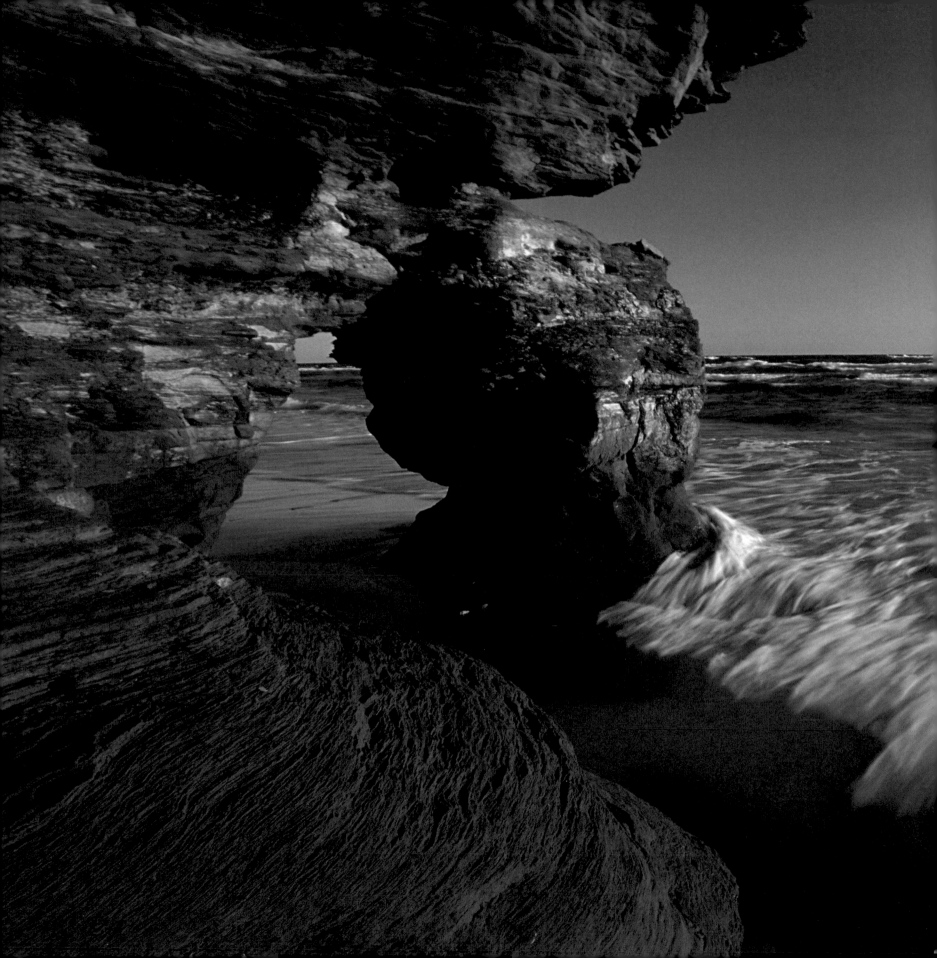

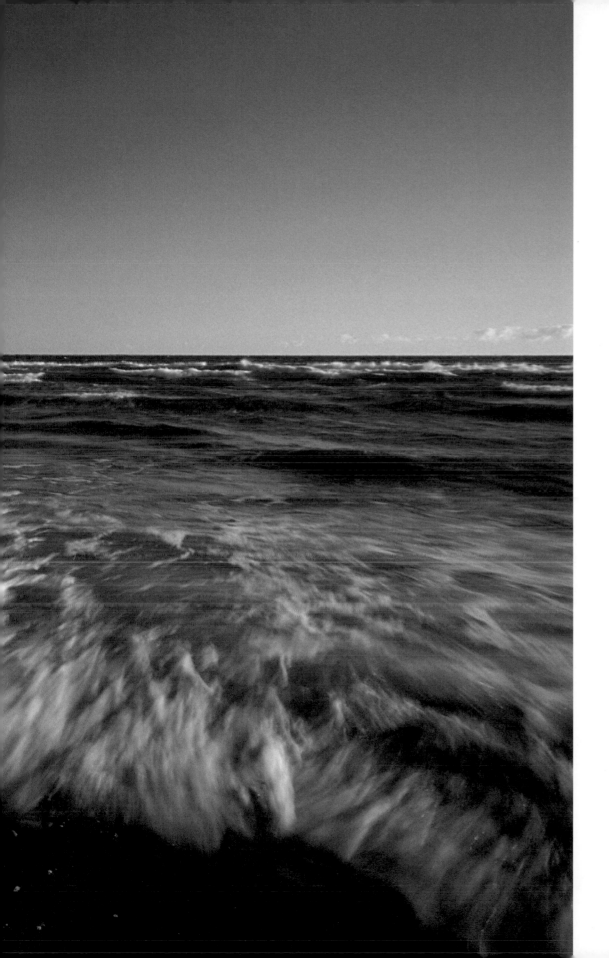

Wave-sculpted cliffs
on the Island's north shore.

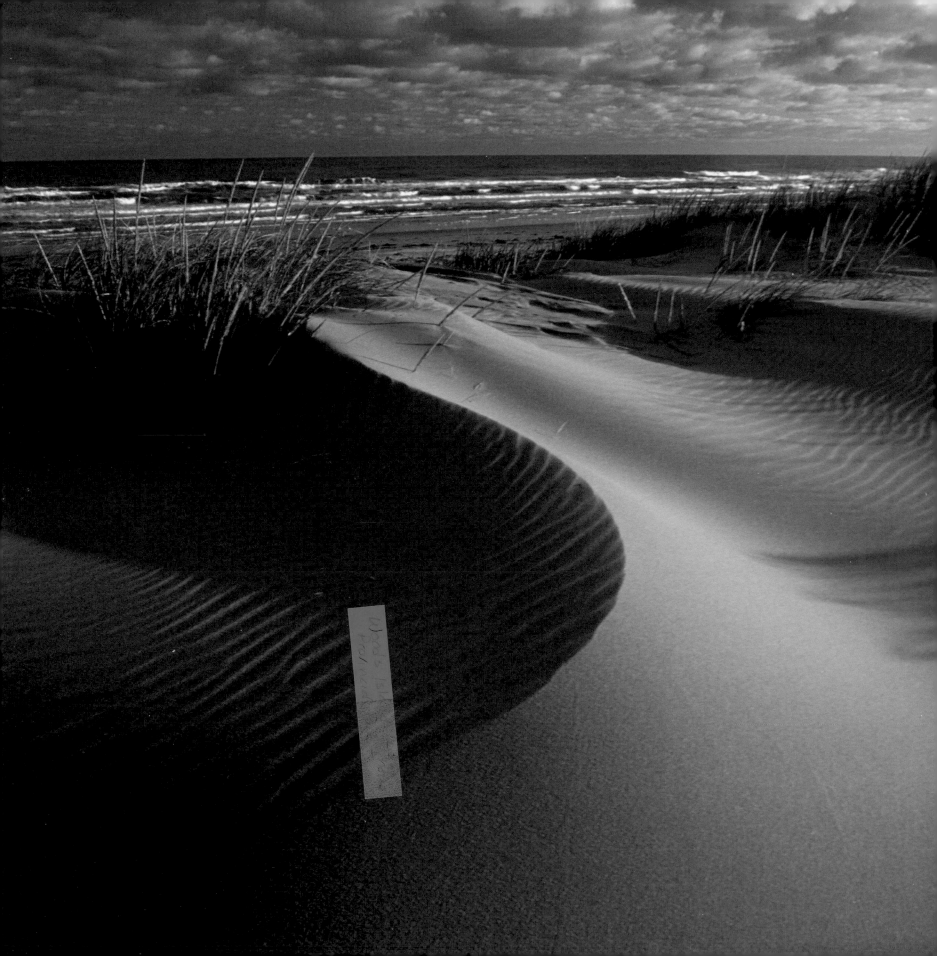

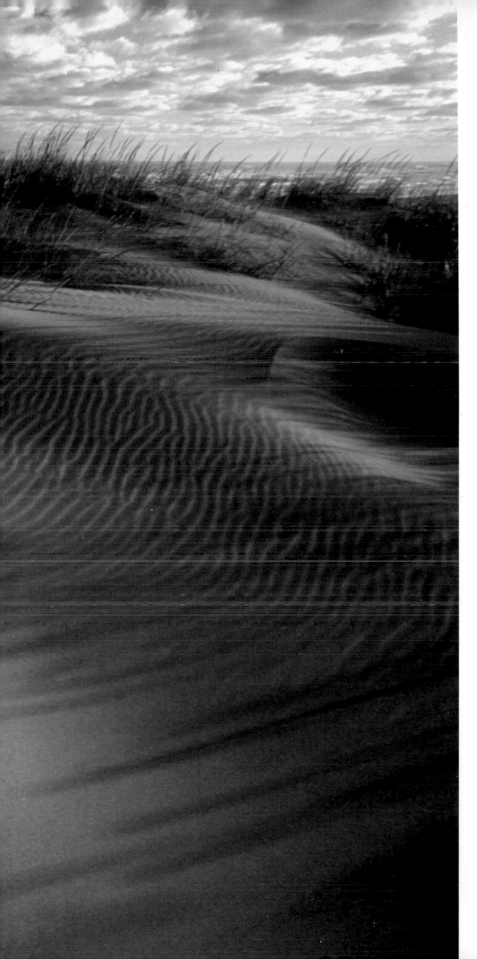

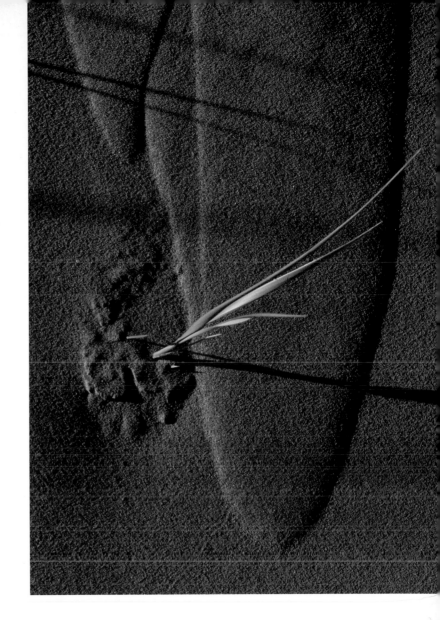

Prevailing winds shape and transform dunes, removing sand from one location and depositing it in another. A dune is formed when blowing sand meets an obstacle, such as driftwood, and begins to form a mound. Over time, a dune may grow to the height of a three-storey house.

New shoots of Marram grass push through the side of a sand dune. The plant's deep fibrous root system holds sand in place, stabilizing the dunes. Marram grass is highly susceptible to damage from human footsteps. As little as ten steps on a plant is enough to kill it, leaving the dune exposed to the wind. In severe cases a blowout will occur — a large section of dune will simply blow away.

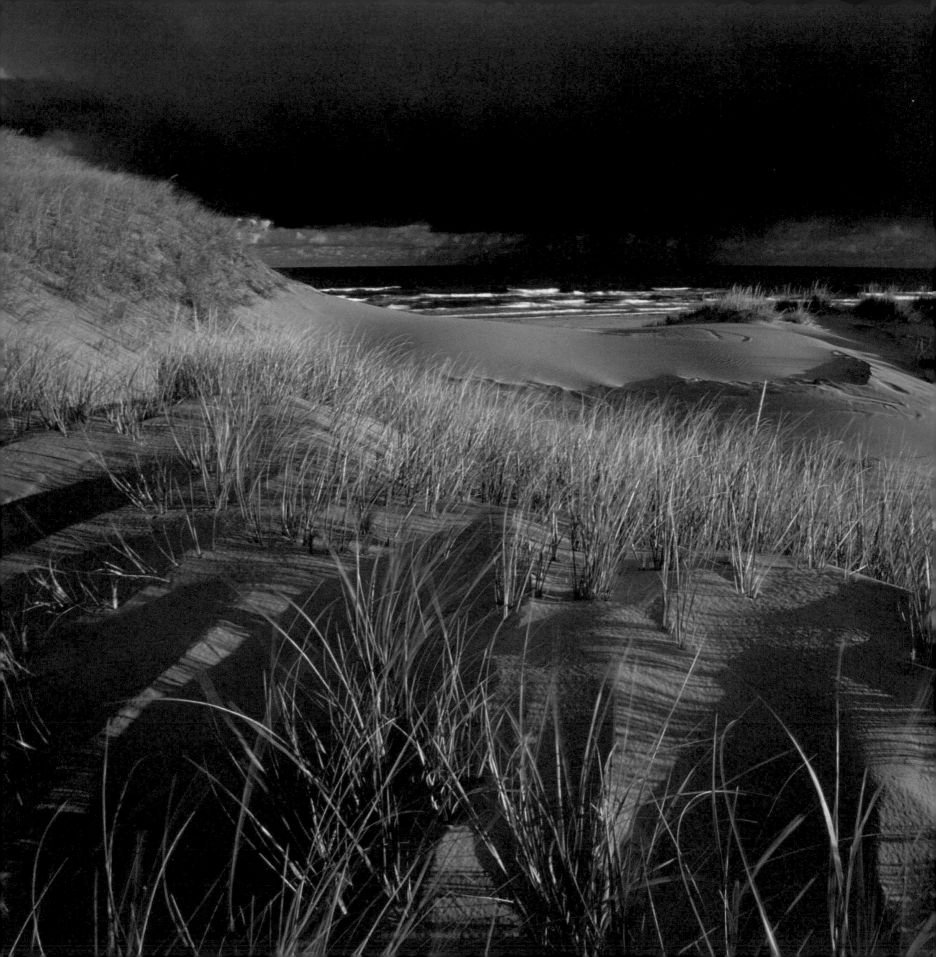

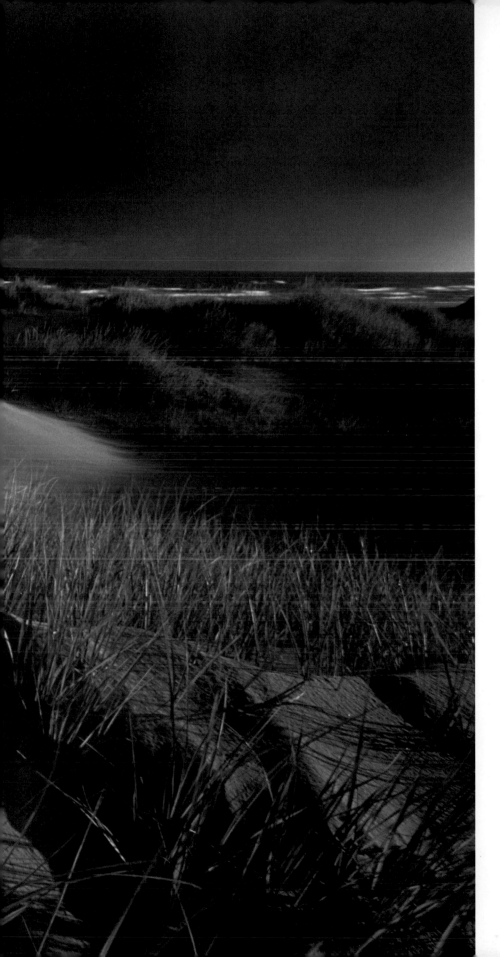

Autumn storm clouds over
the Gulf of St. Lawrence and
Brackley dunes in Prince Edward
Island National Park.

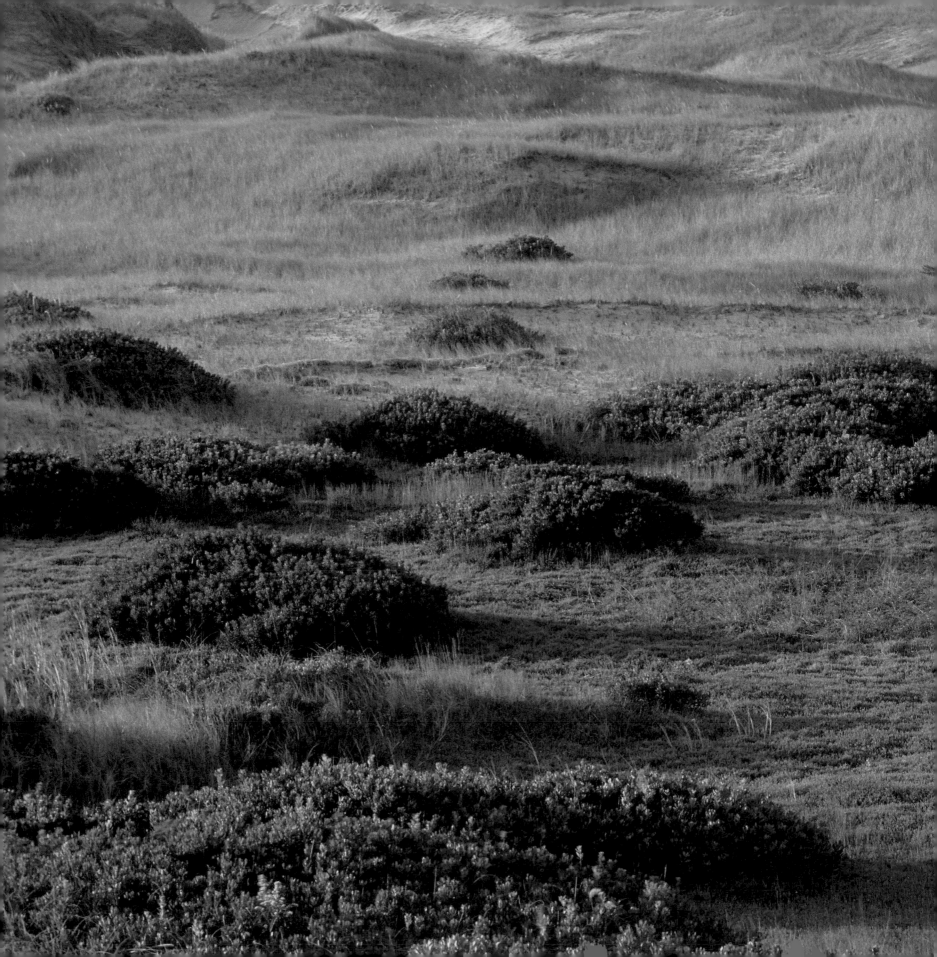

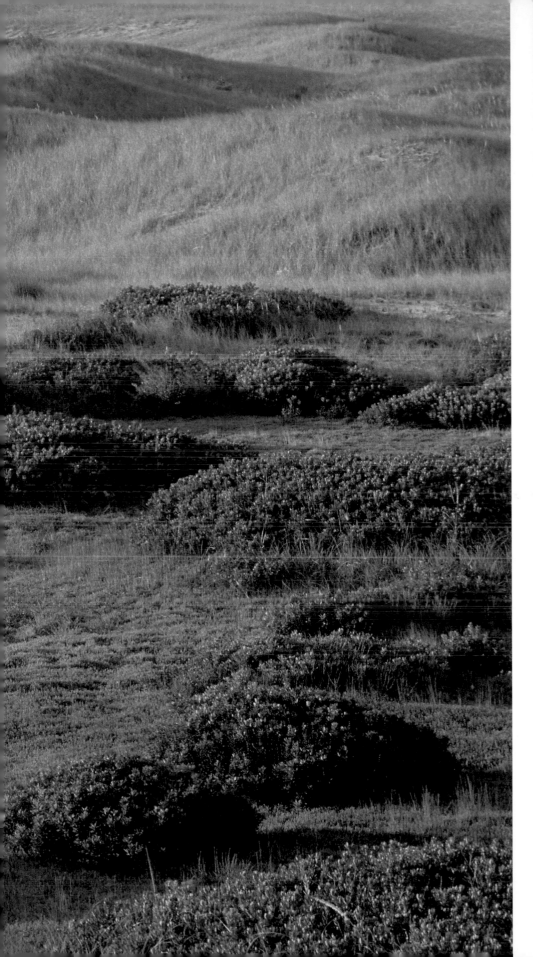

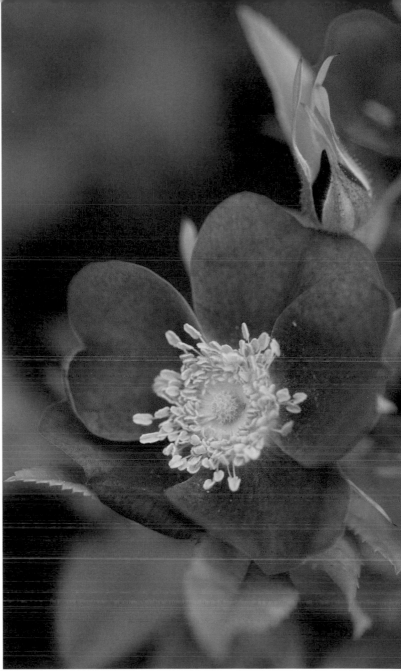

Gegenwalle are low sand ridges formed in the wake of migrating parabolic dunes. They are covered in dune-stabilizing marram grass and low shrubs such as bayberry, cranberry, and wild rose. Greenwich is the only site in North America in which *Gegenwalle* occurs.

Wild rose is one of the first plants to colonize a dune area stabilized by marram grass. Its waxy leaves aid the plant in tolerating the harsh coastal environment.

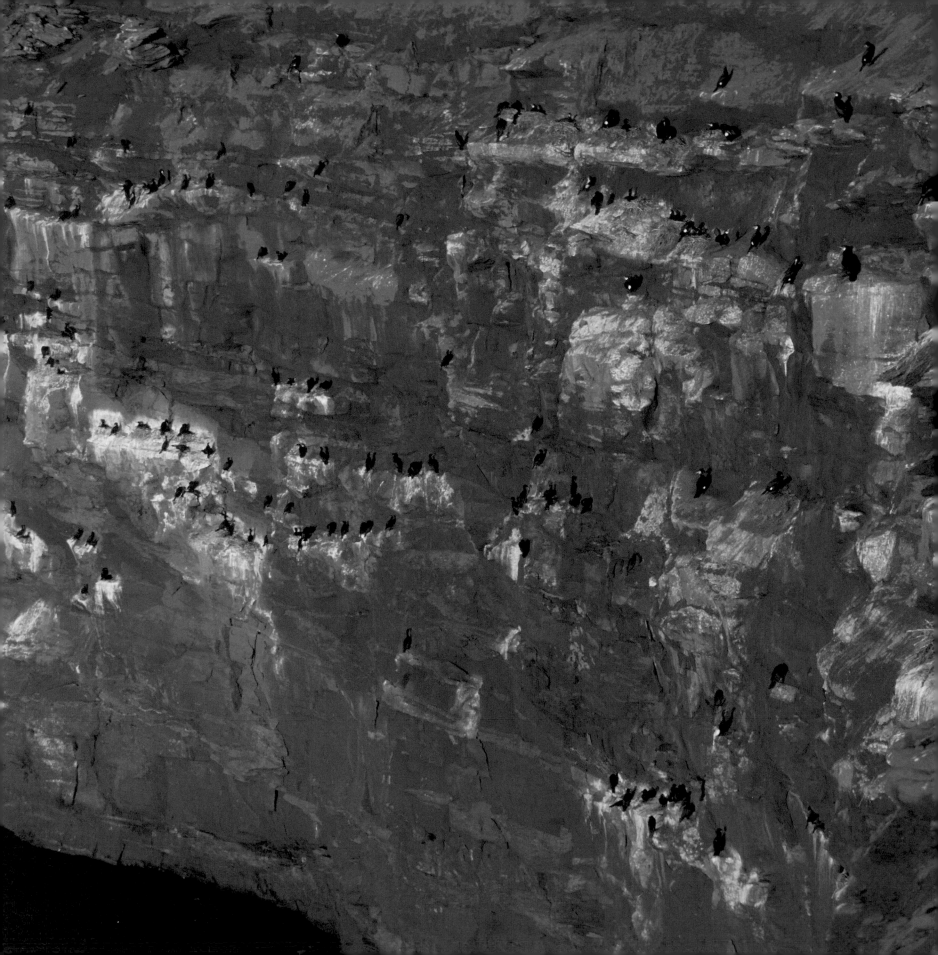

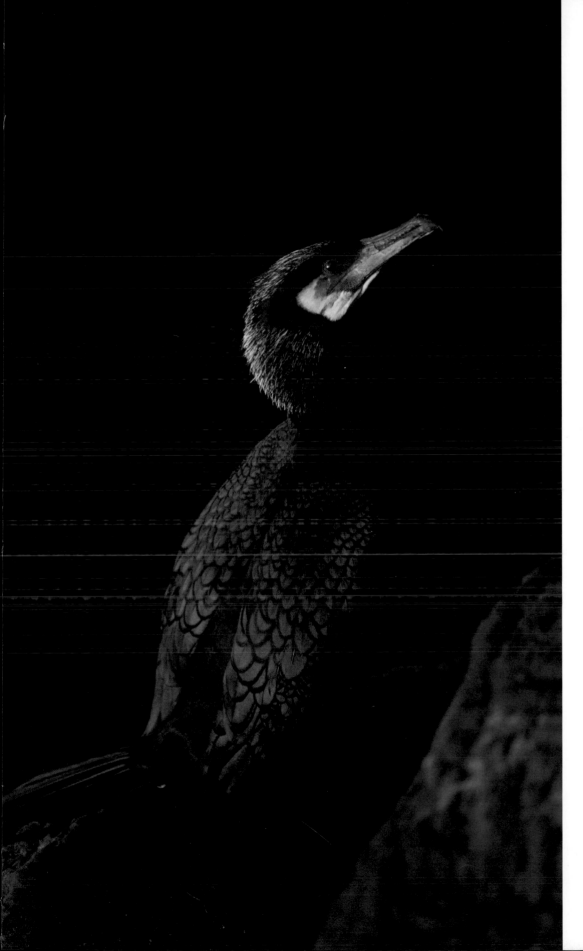

The Island's highest sandstone cliffs, at Cape Tryon, are home to two species of cormorant: the Double Crested cormorant, and the Great cormorant, which is easily identified by its larger size and distinctive white chin patches.

Cormorants have long been persecuted. Their primary sins appear to be their primitive, almost reptilian, appearance and their fish-eating ways. The Bible describes them as an "abomination among the fowls." But like any animal, they are just trying to make a living. They are devoted parents, raising a clutch of four or five eggs in a nest made from twigs, tended by both parents. Adapted for swimming and diving, cormorants don't have the same oily waterproofing on their feathers that some other water birds possess, so they are often seen perched on rocks, with wings outspread to dry. They are also called "shags," which comes, apparently, from their somewhat shaggy appearance when they emerge from the water. The larger Great cormorant is strictly a marine species, nesting on cliffs, while the smaller, much more numerous, Double Crested cormorant nests on offshore islands, trees, and cliffs and is widespread throughout North America in both fresh water and marine environments.

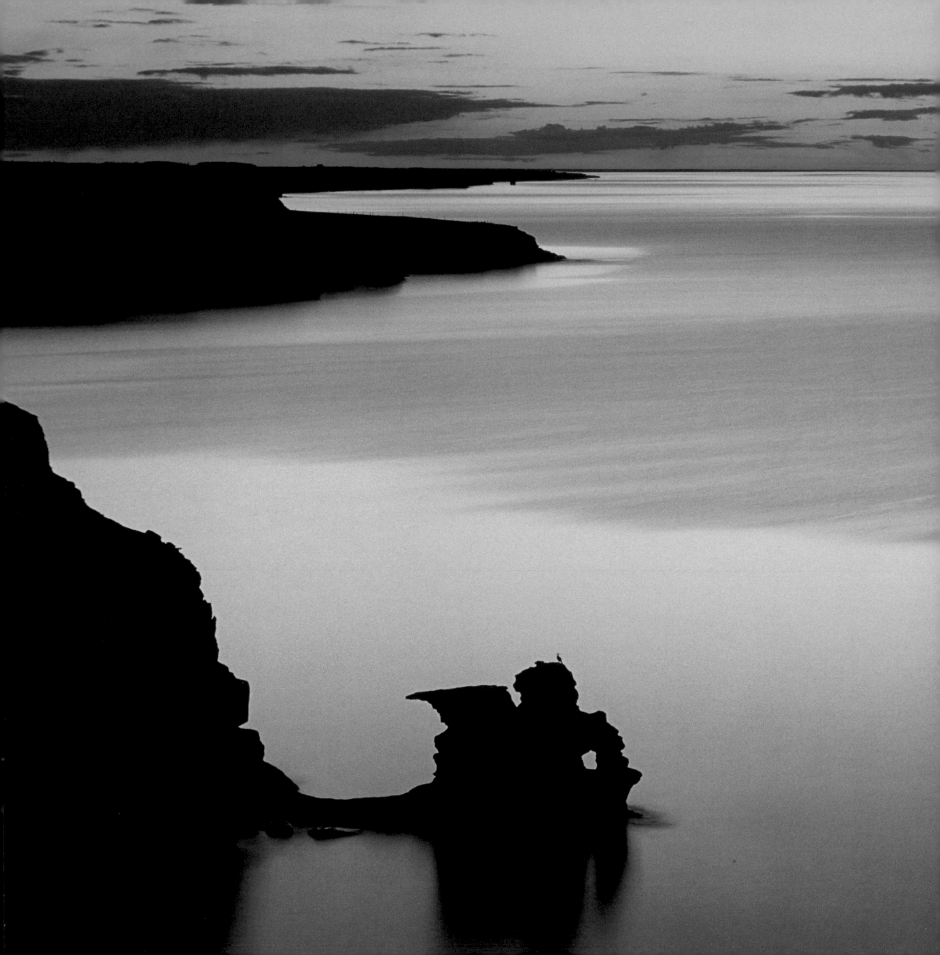

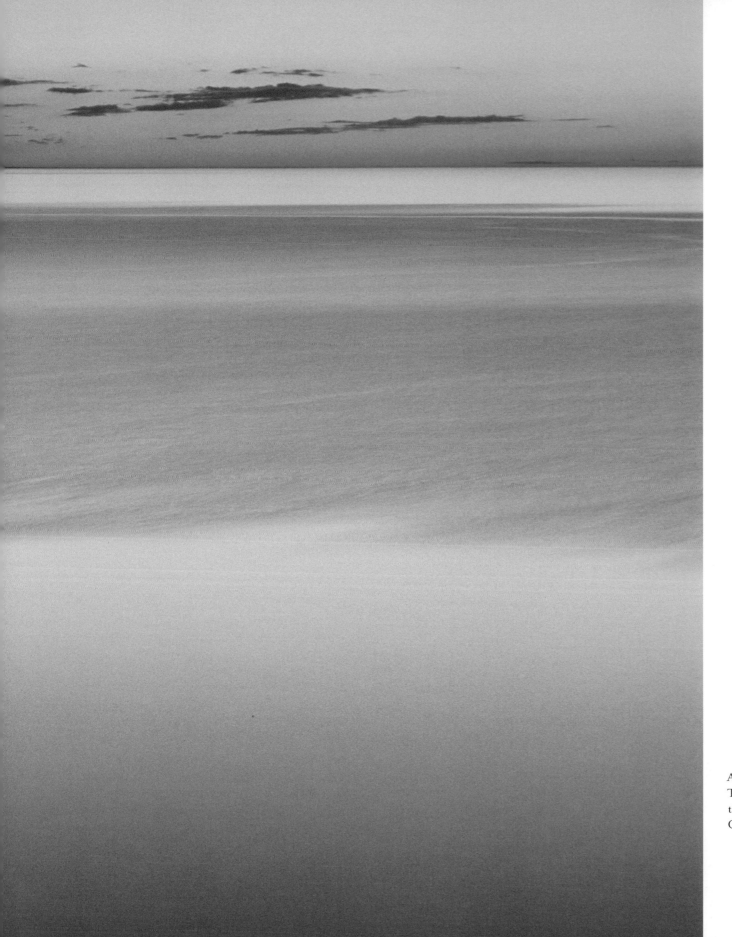

At sunset, the coastline at Cape Tryon is silhouetted against the tranquil surface of the Gulf of St. Lawrence.

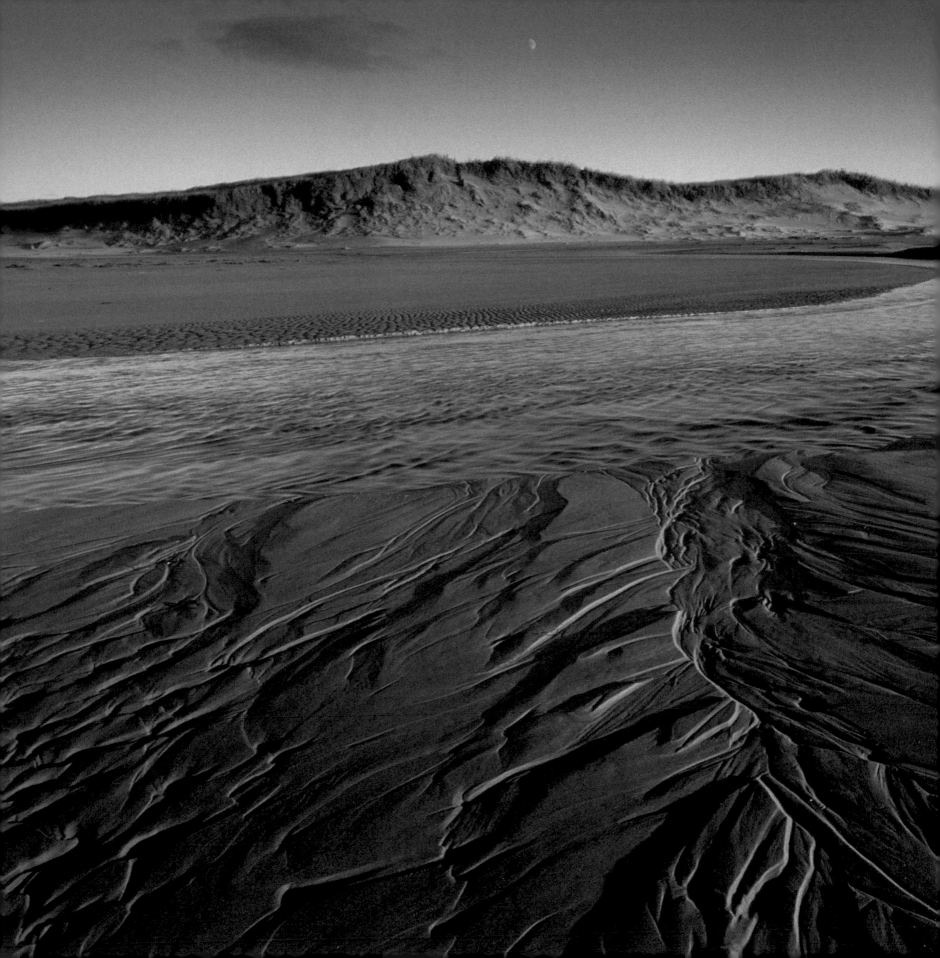

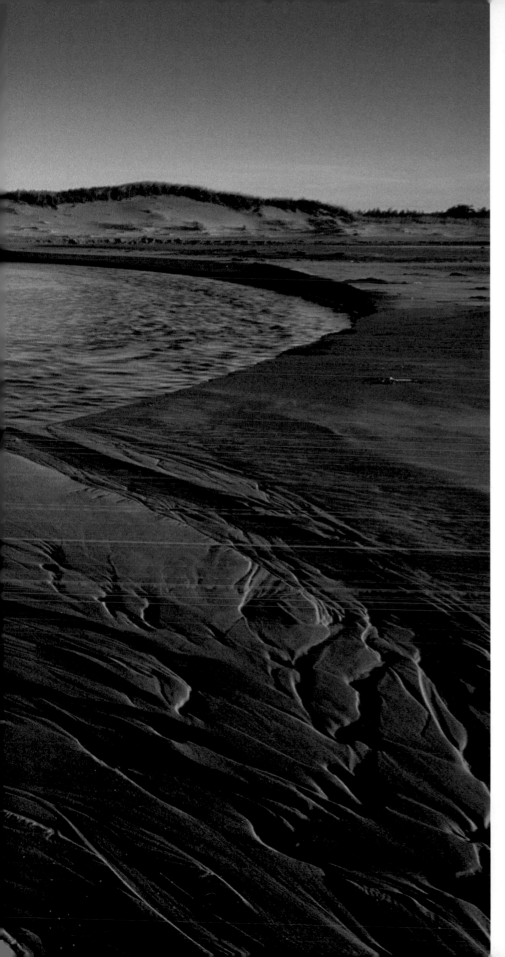

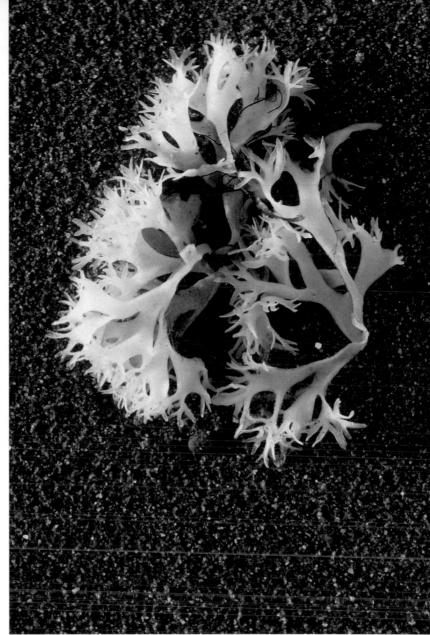

Wind and water shape the beaches and dunes of the Island's coastline. These veined impressions resulted when heavy rains caused a stream to overflow its banks and spread across a beach in Prince Edward Island National Park.

Irish Moss is not a moss, but a seaweed, *Chondrus crispus*, that grows on the ocean floor. When storms loosen it, it floats into the intertidal zone and washes up onto beaches. It is harvested in Prince Edward Island for a substance called carageenan, which is used as a thickening agent in household products such as toothpaste and ice cream.

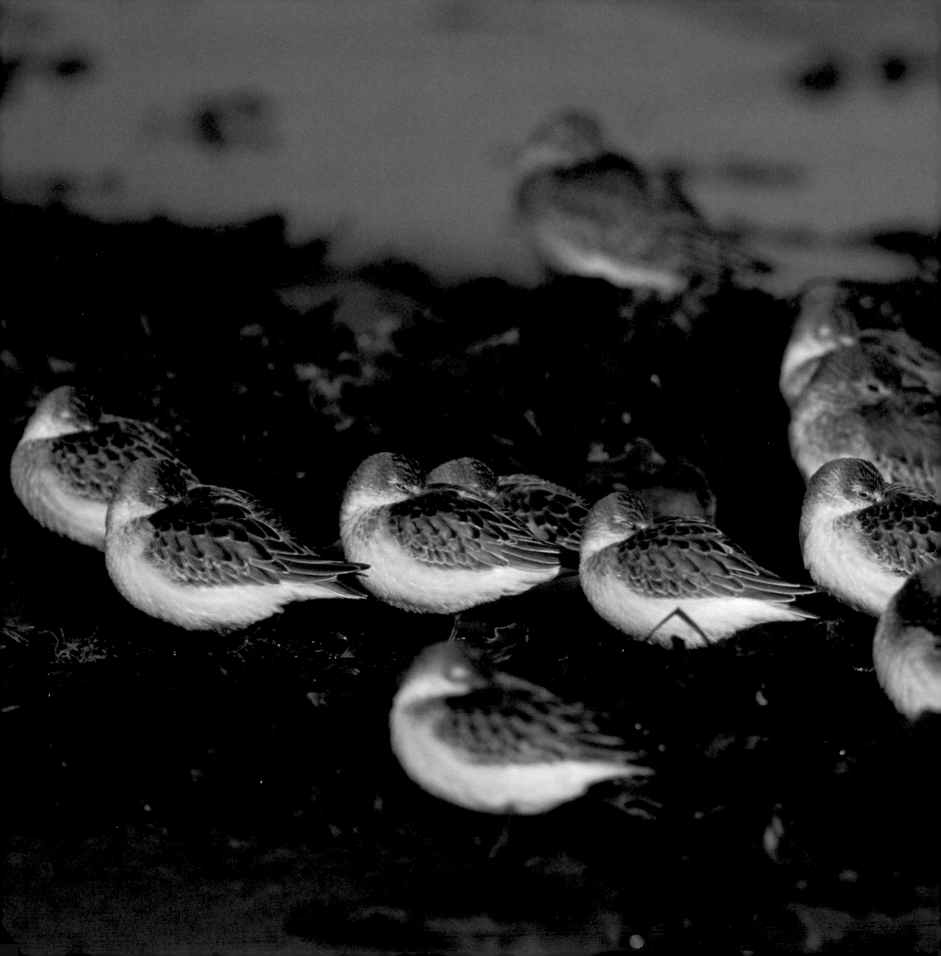

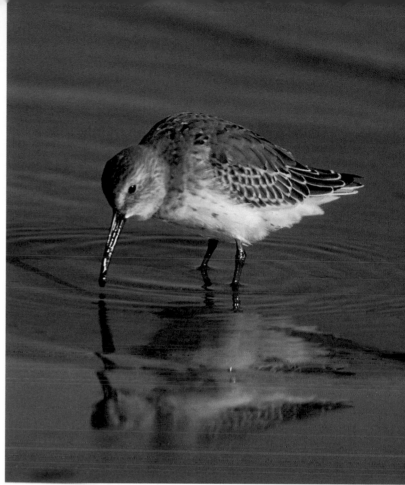

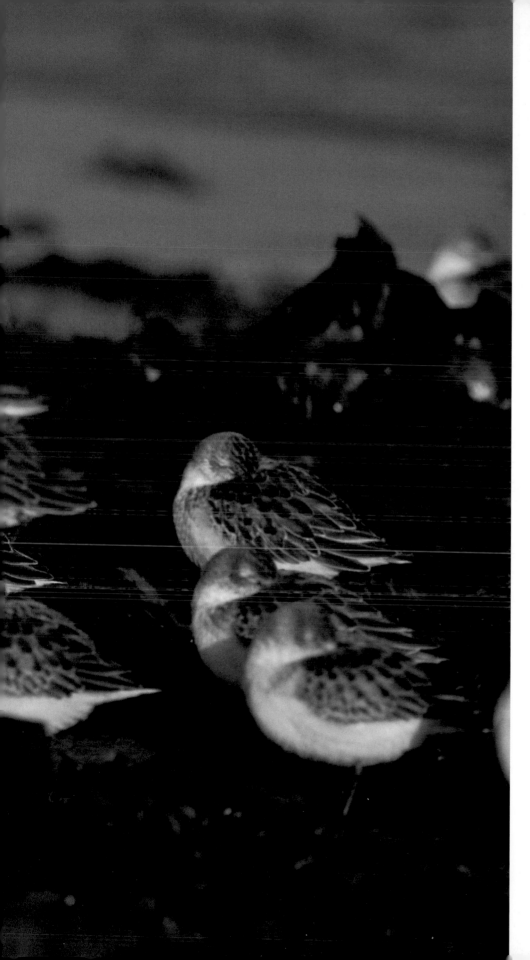

Semipalmated Sandpipers take a beach break during their fall migration. These birds congregate in huge flocks, numbering in the thousands, along the upper Bay of Fundy in mid-August. Although their numbers are far fewer in Prince Edward Island, small flocks are a common sight on Island beaches in the spring and fall. When disturbed, they take to the air en masse, the entire flock twisting and turning in unison. This is thought to be defensive behaviour to foil attacks from birds of prey. One morning, while attempting to photograph a small flock of sandpipers at the edge of a salt marsh, they suddenly burst into flight, swooping frantically over the marsh. I looked up to see a marsh hawk in pursuit. But he was no match for their aerobatics and quickly abandoned the hunt.

A Dunlin, distinguished by its thick downward curving bill and size — slightly larger than a Semipalmated Sandpiper — forages along a beach during the fall migration. Dunlins breed in the Arctic and winter along the coast of Massachusetts south to the Gulf of Mexico, stopping to feed on beaches in the Maritimes during their seasonal flights north and south.

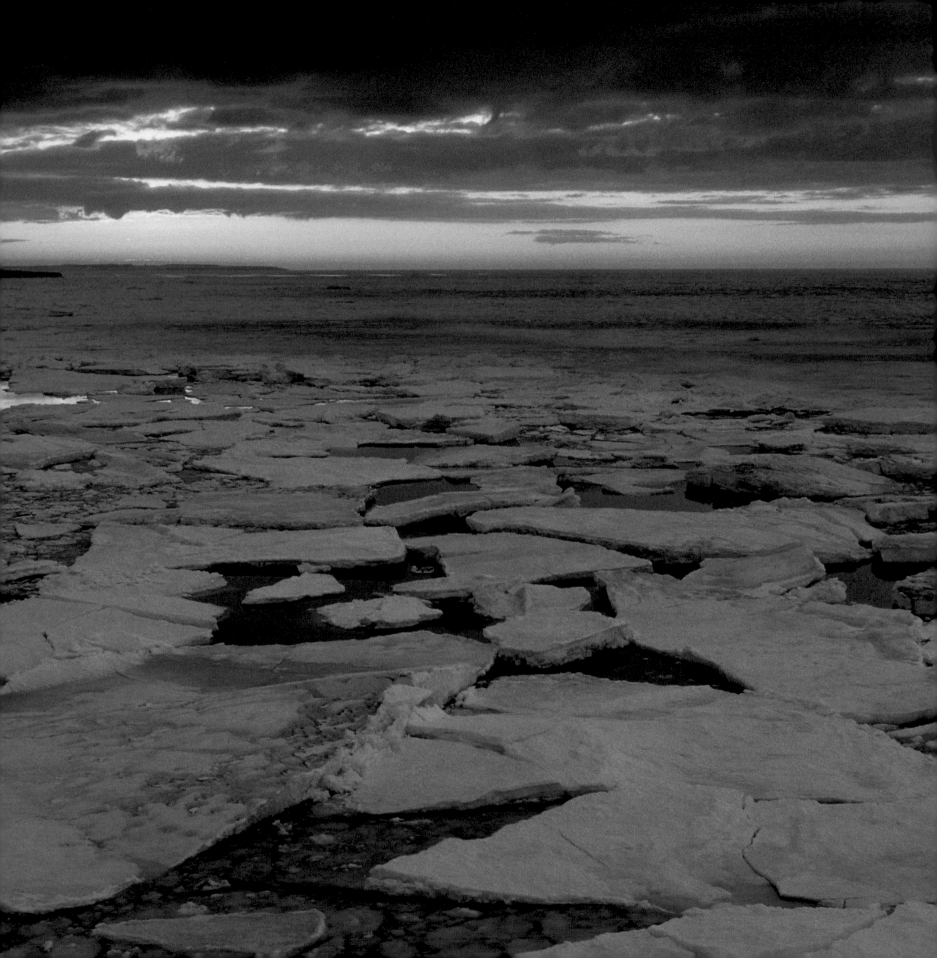

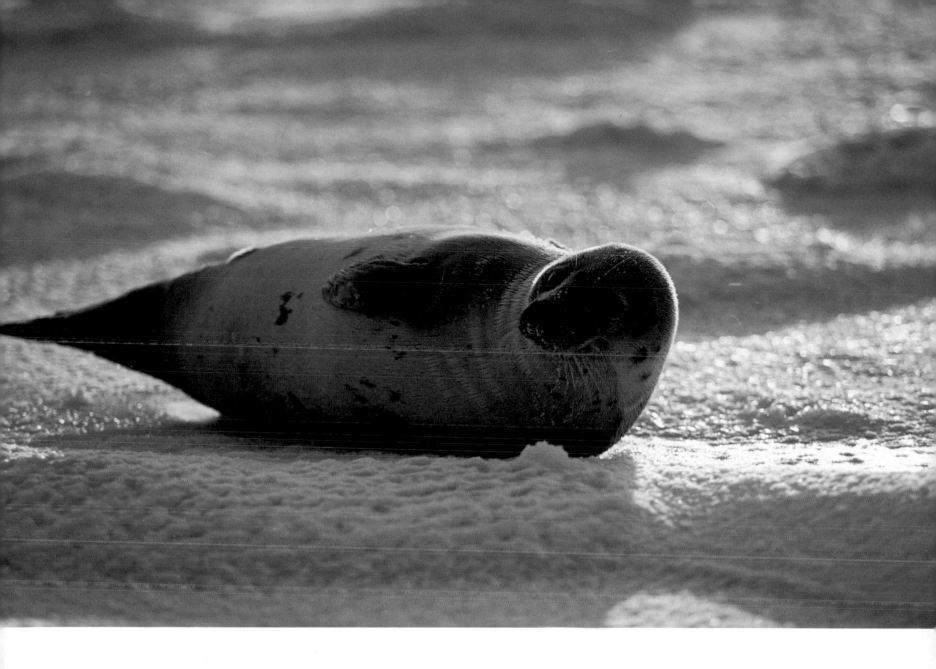

Sea ice begins to disintegrate in the Gulf of St. Lawrence in early spring. For about three months a year, from January to March, the Island is surrounded by ice. It protects the fragile coastline from the erosive effects of winter storms. In recent years, mild winters, possibly due to global warming, have resulted in sea ice forming much later in the season. As a consequence, severe storms have damaged the dunes and eroded headlands — a sign that global climatic change could have a profound effect on the future of the Island's coastal environment.

A Harp seal rests on the ice after being blown ashore by an early winter storm. In late winter, large herds of harp seals haul themselves onto the sea ice north of Prince Edward Island, in the Gulf of St. Lawrence, to give birth to their pups, called Whitecoats. The white-furred, doe-eyed pups have been at the centre of a forty-year battle between animal rights activists and local sealers. It is no longer legal to hunt the pups, but an annual hunt for adult seals continues amid controversy.

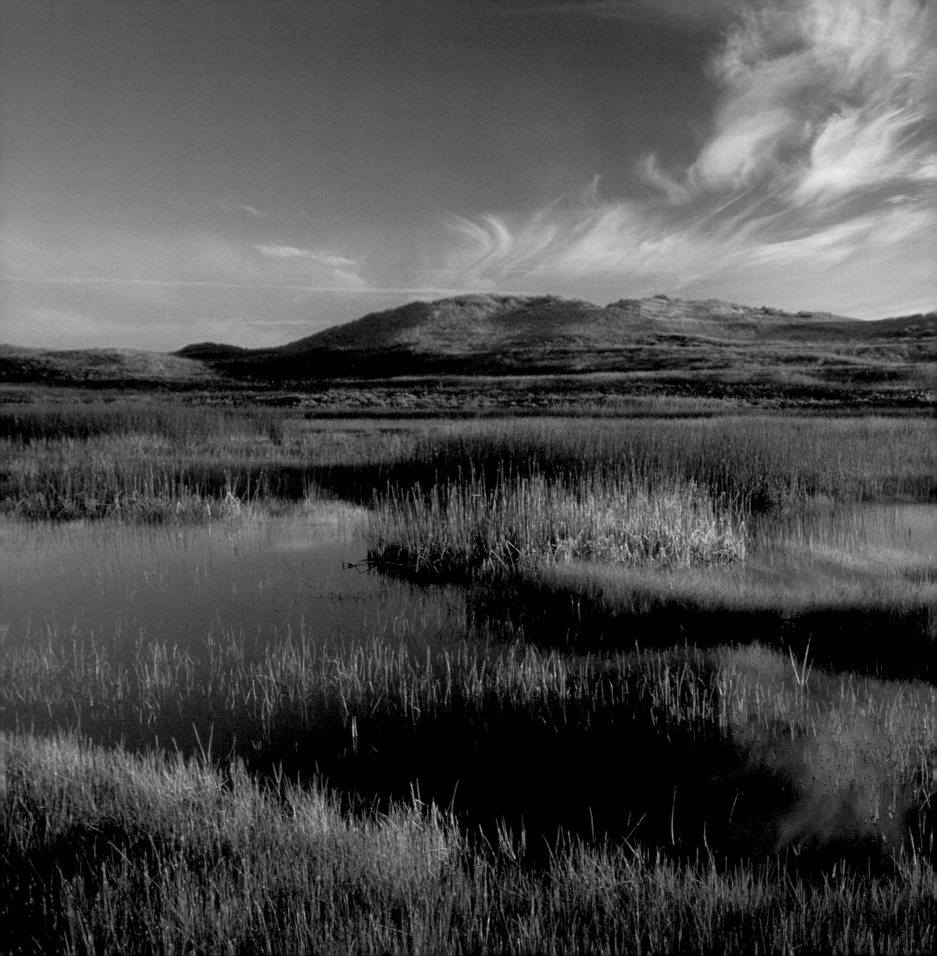

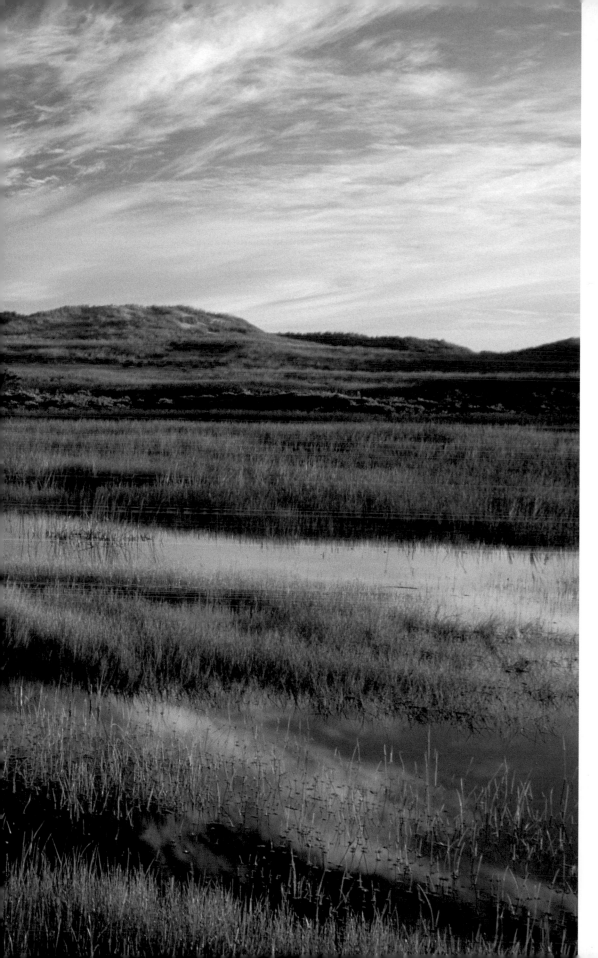

After a heavy rainfall, a temporary pond is formed in a depression behind the Brackley sand dunes in Prince Edward Island National Park. The landward side of dunes, called the dune "slack," is stabilized by deep-rooted marram grass, which in turn allows low shrubs to take root, further stabilizing the dune.

In mid-summer, fireweed blooms in the dune slack.

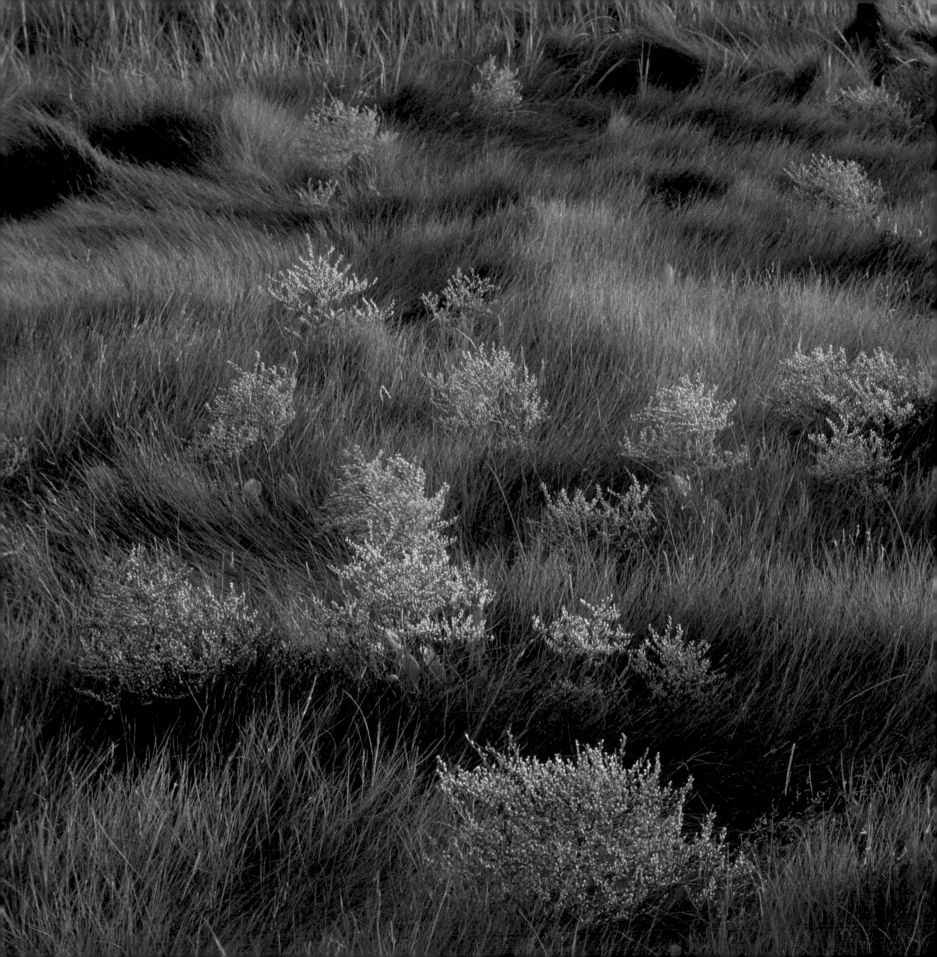

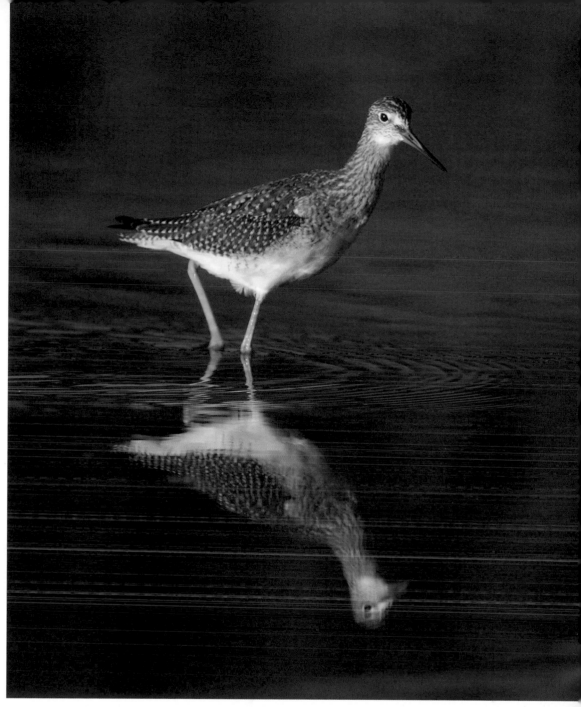

Sea Lavender grows amidst the predominant cordgrass in saltwater marshes throughout the province. It blooms from July to October and is easily identified by its delicate lavender-pink flowers, from whence it derives its name.

The Lesser Yellowlegs is a common sight in Island wetlands and shallow streams, where they feed on aquatic insects, small fish, and crustaceans. They catch their prey on the water's surface, or just below the surface, rather than probing the sand with their bills as most sandpipers do. They will wade into the water up to their belly and have also been known to swim, a unique behaviour among shorebirds. Yellowlegs are extremely alert, bobbing their neck up and down when approached, before flying off to a safer distance.

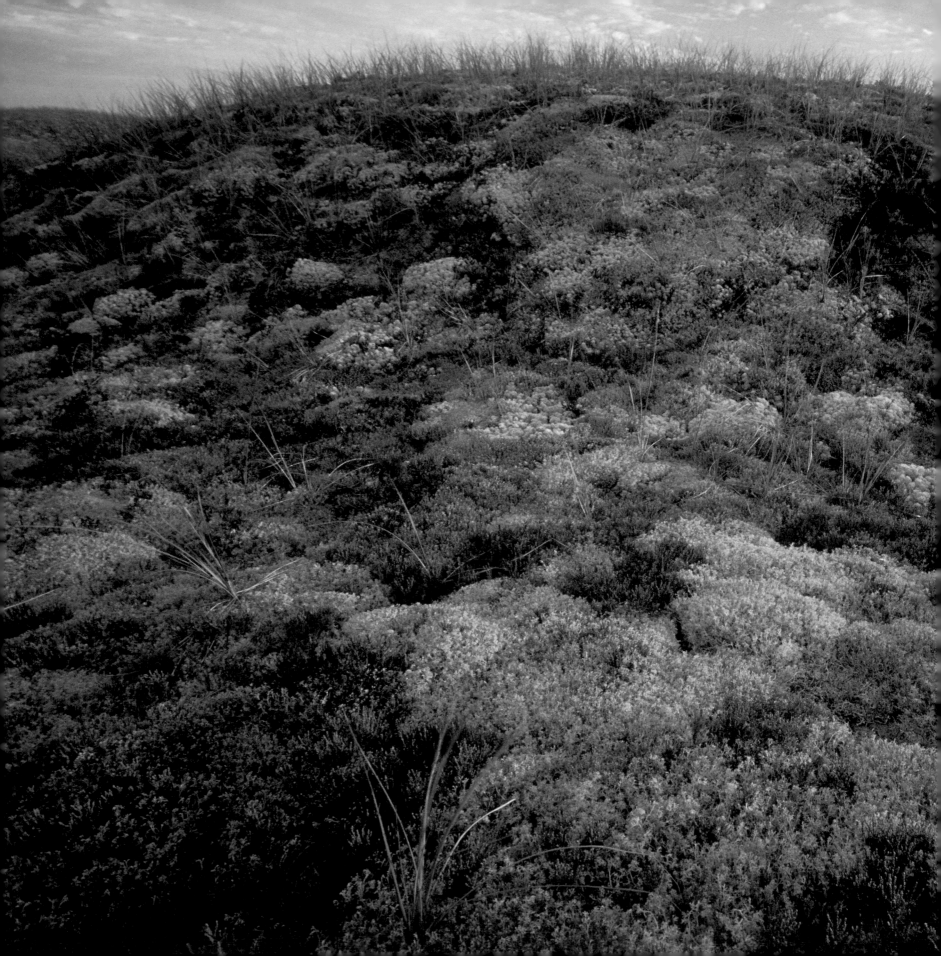

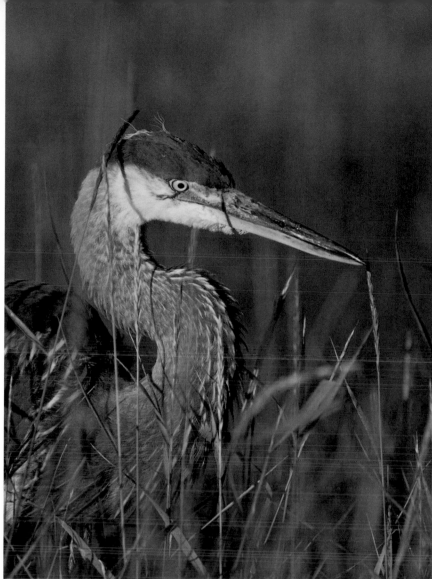

A colourful mosaic of lichens and hardy, salt-tolerant, evergreen shrubs flourish in the dune "slack" at Black Pond, in eastern Prince Edward Island.

The Great Blue Heron is probably the most recognizable wetland bird in Prince Edward Island. They are found throughout the province feeding in shallow bays, freshwater ponds, and salt marshes. Sometimes incorrectly referred to as "cranes," they are, in fact, the largest heron in Canada, standing over one metre tall, with a wingspan of almost two metres. They hunt in shallow water, standing motionless for several minutes with their head cocked at a forty-five-degree angle. When a fish swims within range, the heron strikes with lightning speed, plunging its head into the water to grab the fish in its rapier-like bill. Raising its head, it gulps the fish down whole. Although fish are their primary food, they will also eat frogs, shellfish, and small rodents. Prince Edward Island is home to the largest concentration of Great Blue Herons in Atlantic Canada.

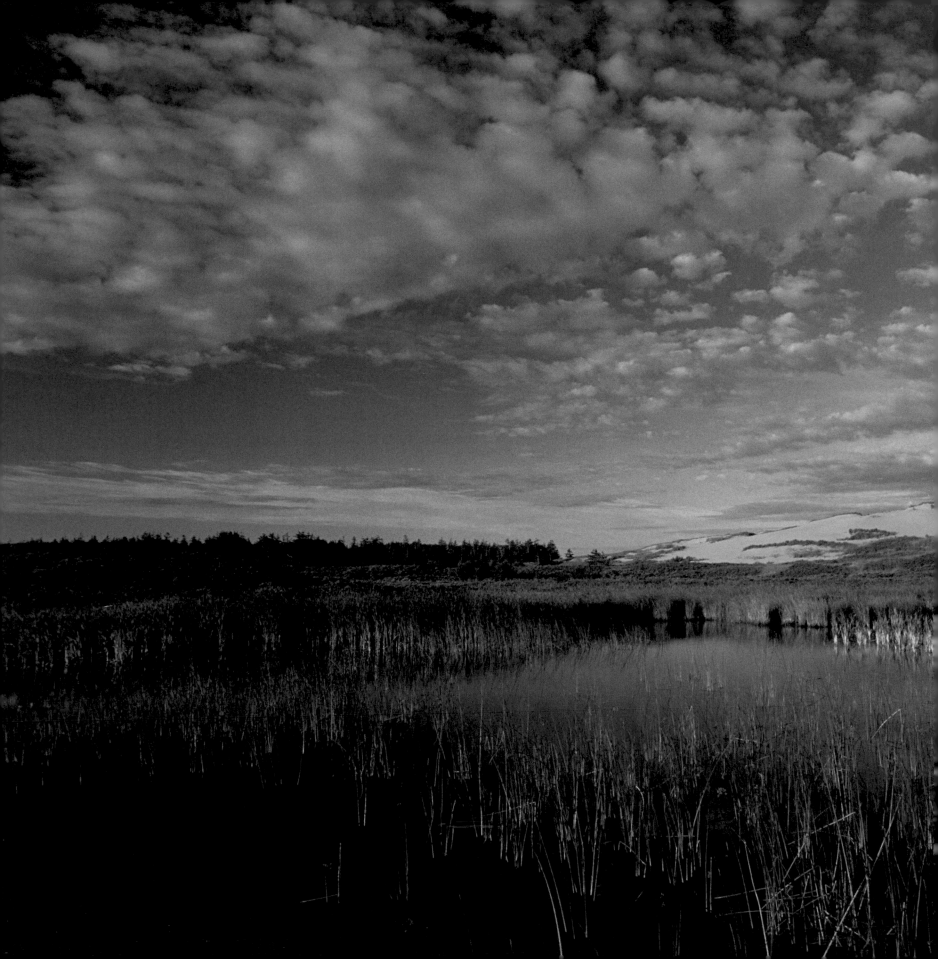

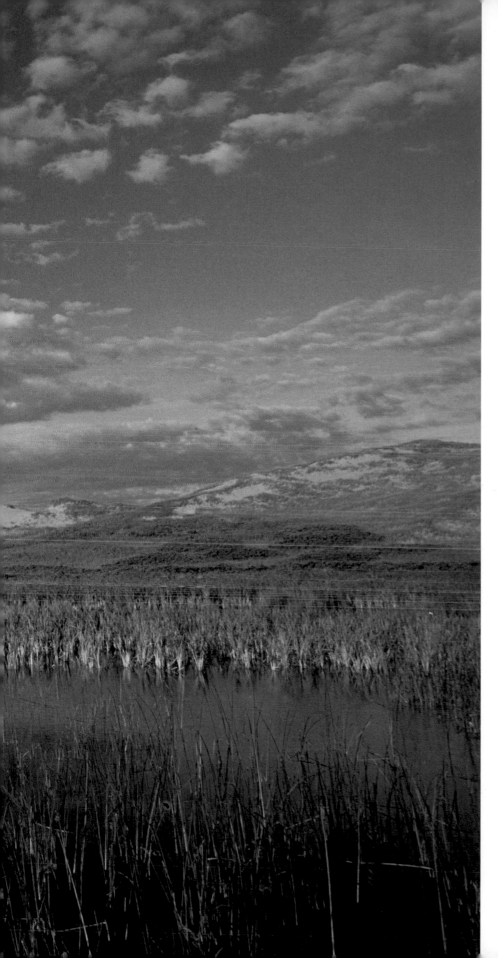

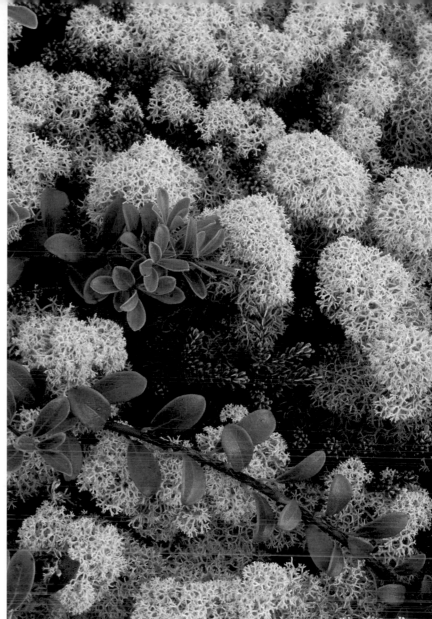

Boley Pond, located behind the Greenwich dunes in Prince Edward Island National Park, is just one of many barrier, or barachois, ponds strung out along the Island's coastline. They are formed when migrating dunes, pushed by wind and tide, close off the entrance to a bay. Cut off from the ocean, the body of water eventually desalinates to become a freshwater pond.

A close-up view of Reindeer Moss and the evergreen shrubs, Bearberry and Black Crowberry. Despite its name, Reindeer Moss is actually a lichen. Lichens are composed of two separate organisms, alga and fungus, in a symbiotic relationship to form a new plant. The algae have chlorophyll and are capable of making their own food while the spongy threads of the fungus provide support.

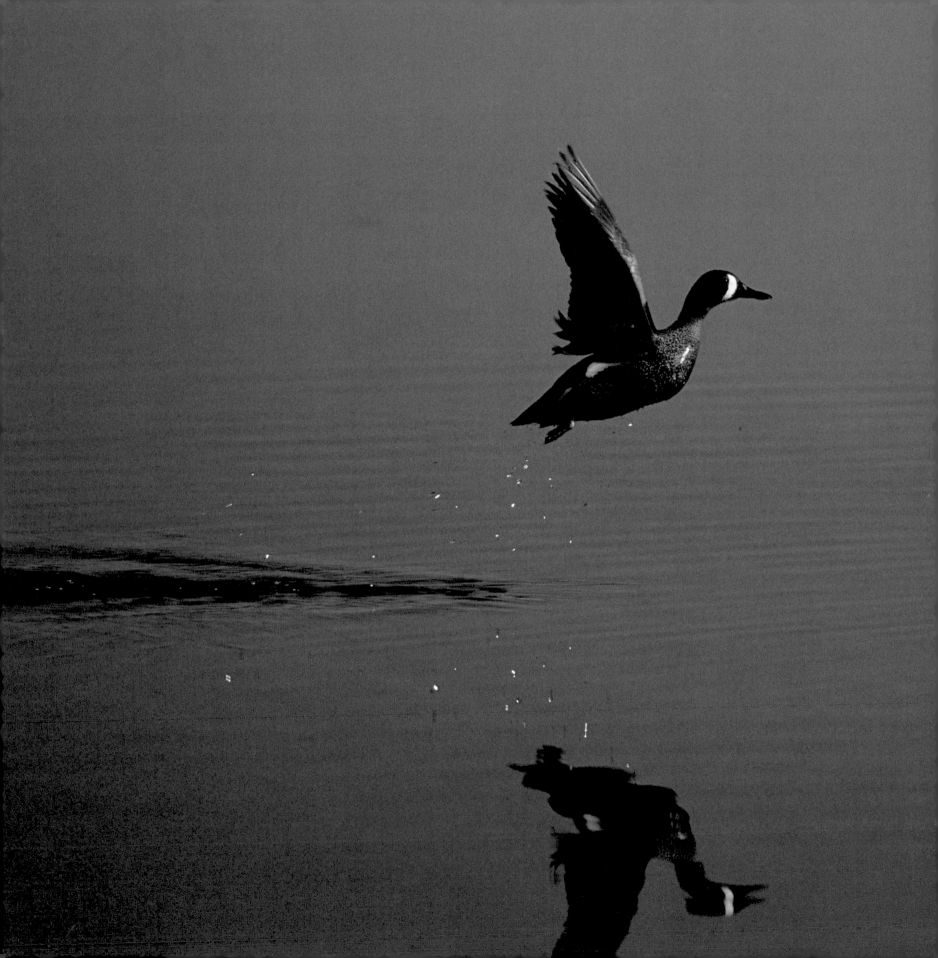

A male Blue Winged Teal takes flight at the first sign of danger. These small surface-feeding ducks prefer freshwater ponds, concealing their nests in dense vegetation near the water's edge. They are one of the last ducks to arrive in spring and the first to leave in the fall.

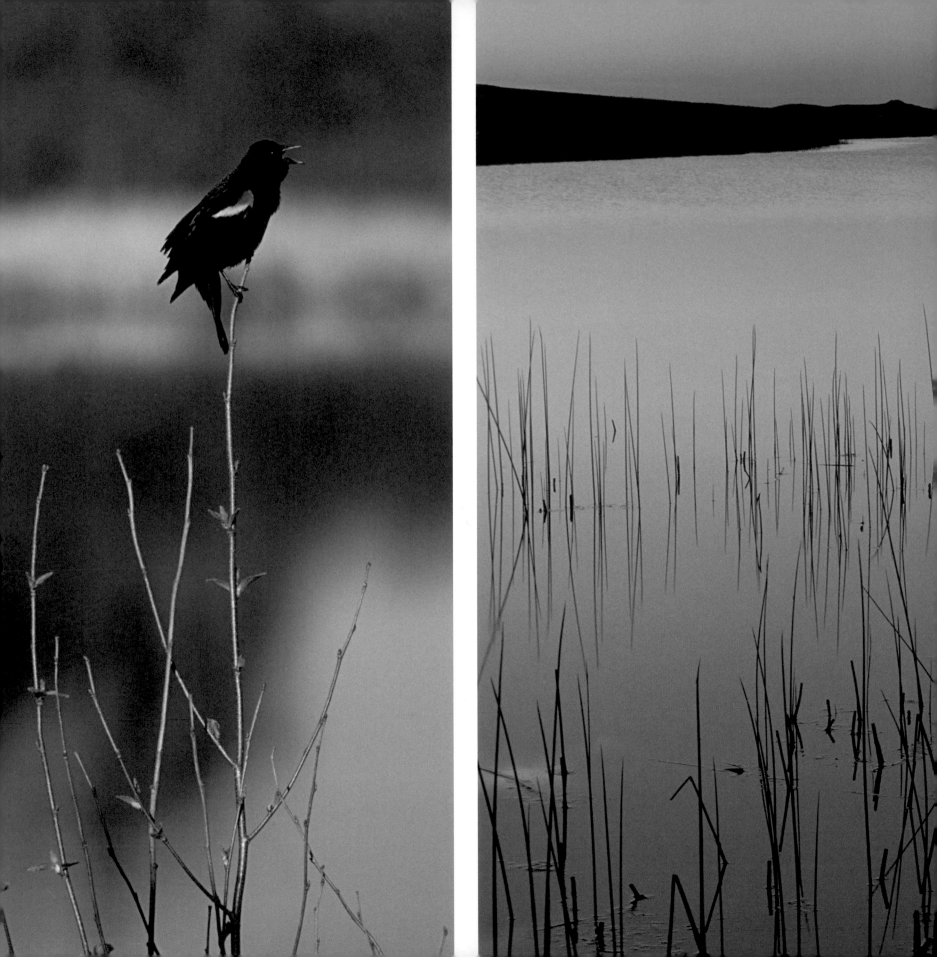

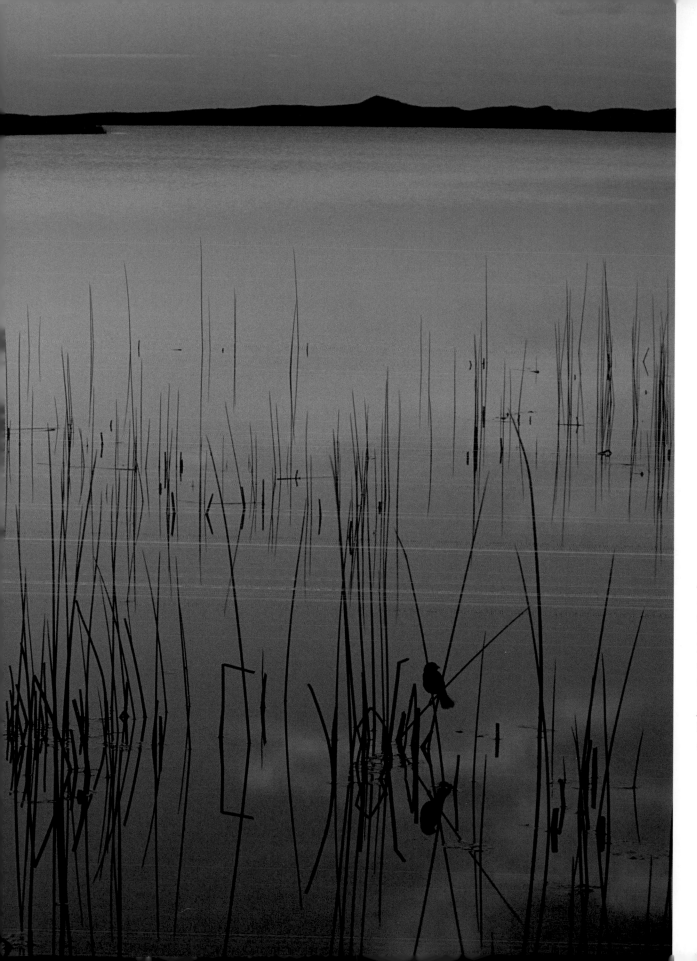

A male Red-Winged Blackbird announces its presence. These familiar wetland birds arrive early in the spring — usually in late March — to stake out their territories and find a mate, aggressively fending off trespassers.

At sunset, a female Red-Winged Blackbird clings to reeds along the shore of a freshwater pond.

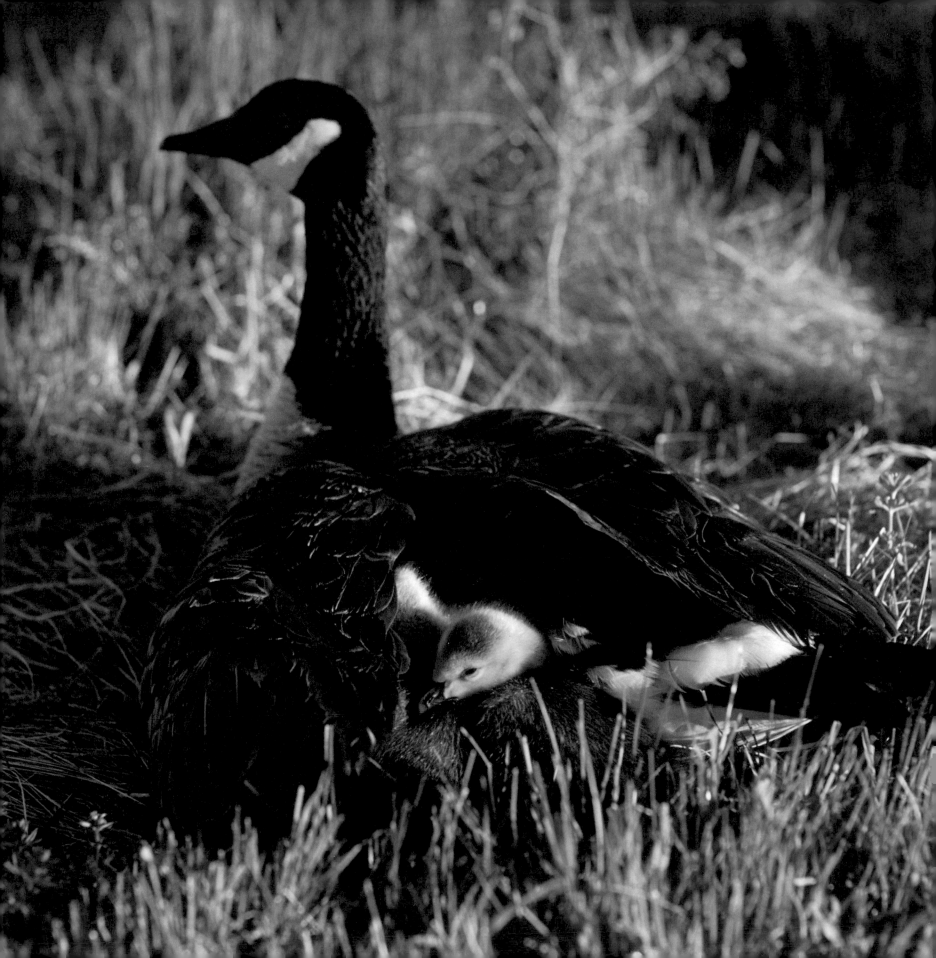

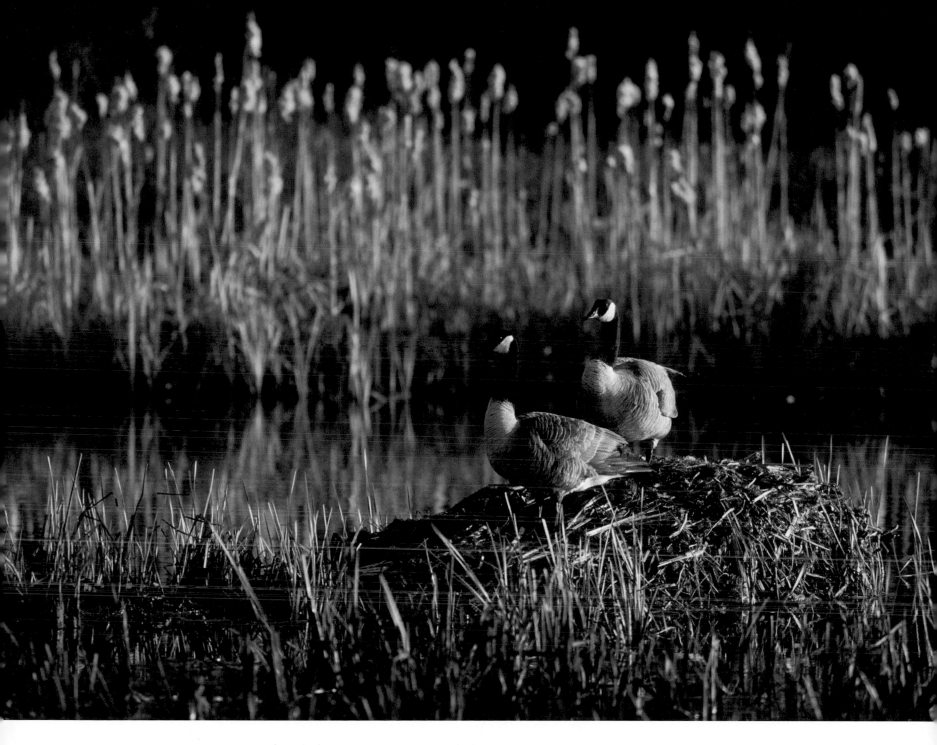

Canada Geese announce the arrival of spring in Prince Edward Island and throughout the temperate regions of North America. Most flocks are passing through the region on their way to breeding grounds in Labrador and Northern Quebec, but some stay to breed and raise their young on the Island. Geese mate for life, favouring nesting sites near water or on small islands where there is a clear view to spot approaching predators. They are early nesters, beginning as soon as conditions are favourable, from mid-March through April and early May. The female lays five to seven eggs, incubating them for about twenty-eight days. Once hatched, the young leave the nest to feed on grasses and sedges along ponds and waterways, returning to the comfort and safety of their mother's feathers to rest. The male, or gander, stays close and will vigorously defend his offspring from predators by delivering a powerful blow with his wing. The family unit stays together until fall when they once again join with other geese for the trip south, announcing the coming of winter as they go.

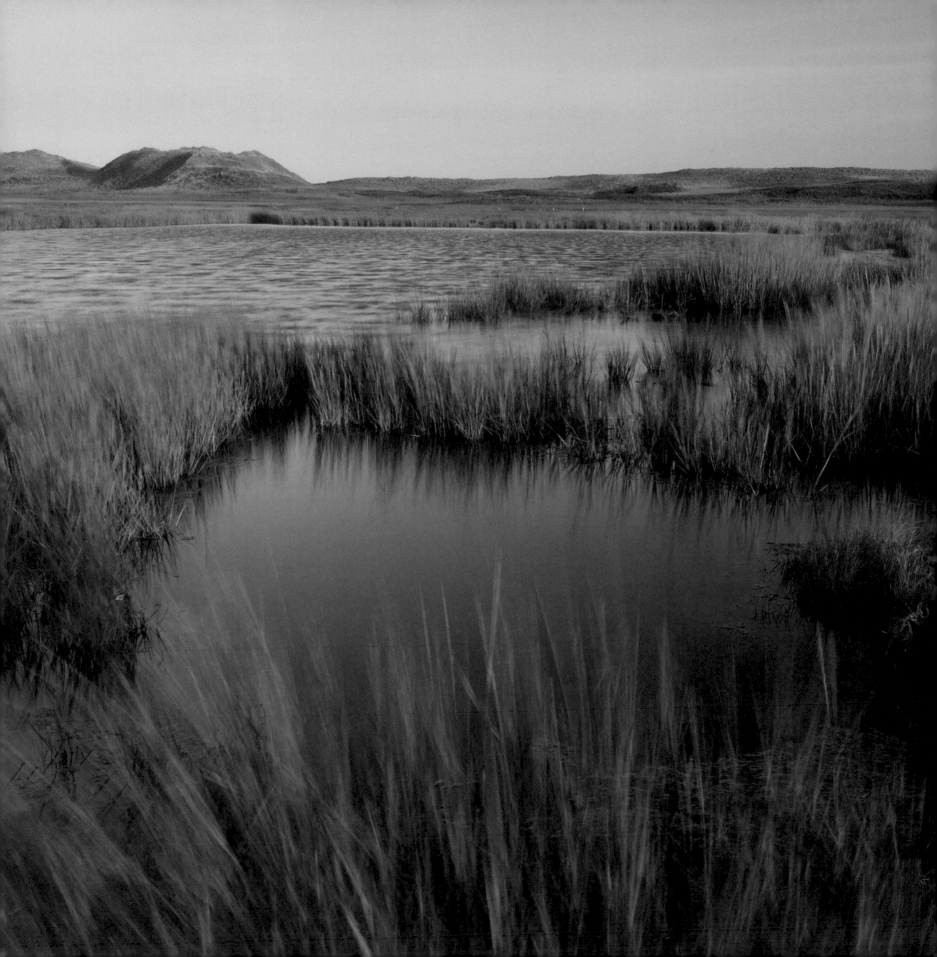

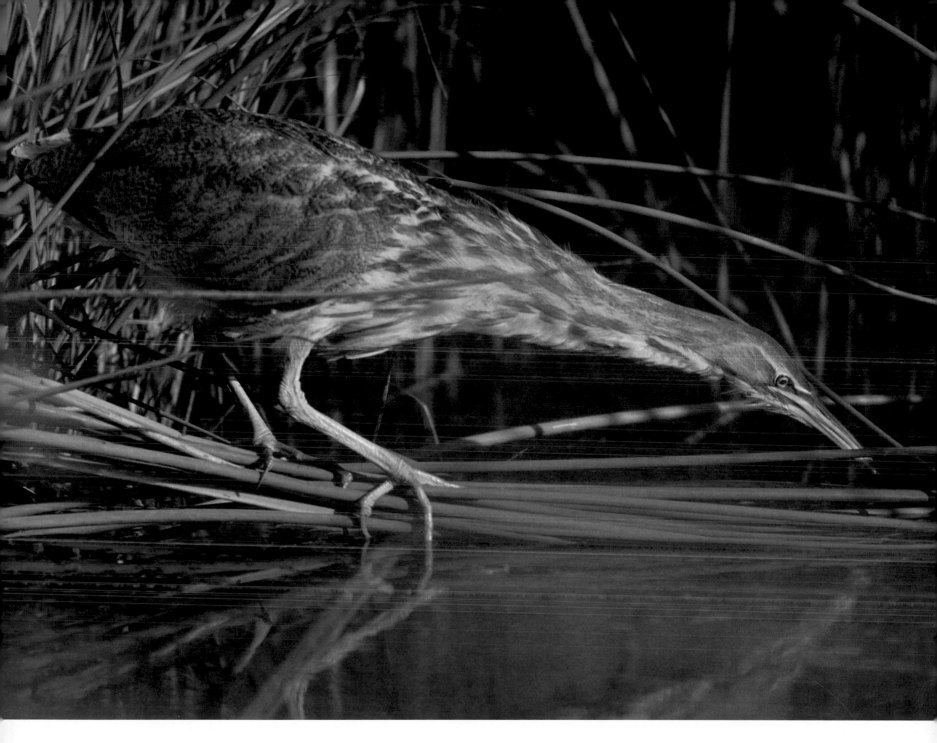

A recluse of the marshes, the American Bittern is a fairly common wetland inhabitant, but sightings are rare. When alerted to danger, they stand stock still with their beak pointed skyward, making them almost impossible to spot amongst the bulrushes. They are so adept at disguise that on windy days they've been known to sway in sync with the surrounding marsh vegetation to avoid detection. Their mechanical sounding "song," a loud "unk-a-chunk," has earned them the nickname "Thunder Pumper." They also make a loud "kok, kok, kok" when alarmed. This fellow was so intent on hunting that I was able to approach quite closely. He allowed me to photograph him for several minutes before he resumed his reclusive ways and vanished into the marsh.

A salt marsh located behind barrier dunes on the Island's north shore near Lakeside.

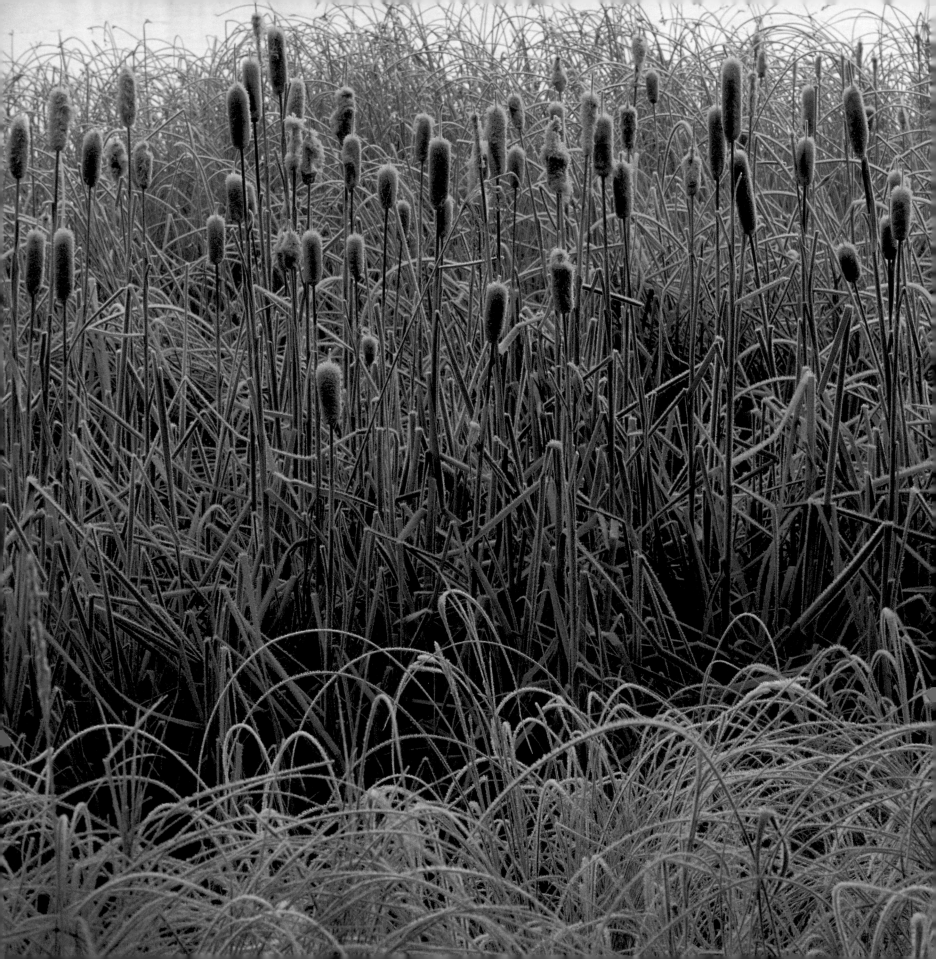

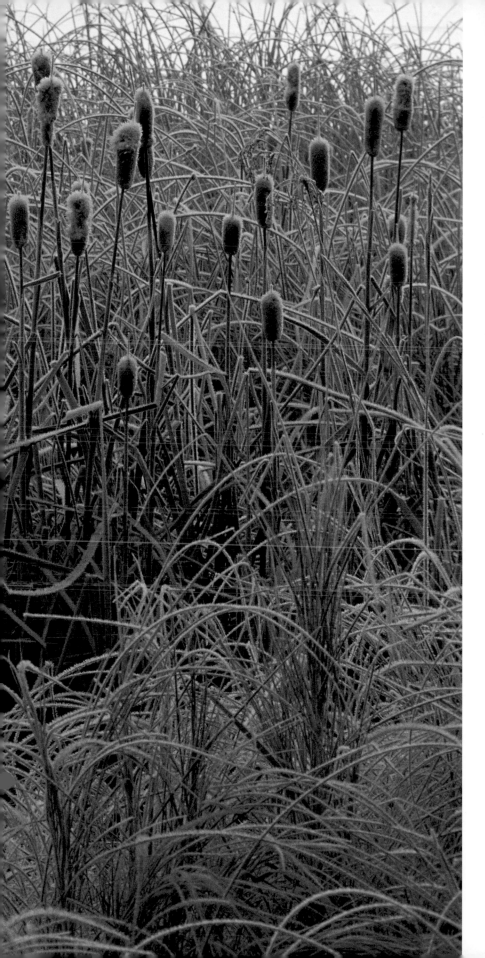

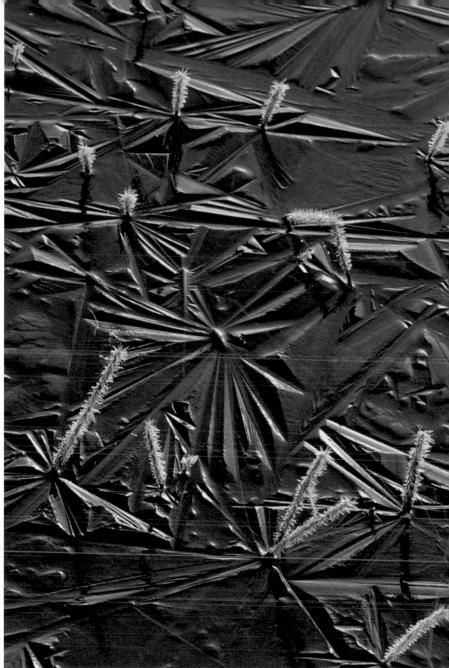

New ice and frost on the surface of a freshwater pond in Prince Edward Island National Park.

Early winter frost gilds bulrushes and sedges along the edge of a freshwater pond in Prince Edward Island National Park. The bulrush is probably the most familiar freshwater plant, with its distinctive brown seed head. It is found throughout the Island's ponds and rivers. Their rapid growth rate allows them to reach heights of nine feet or more within a single growing season.

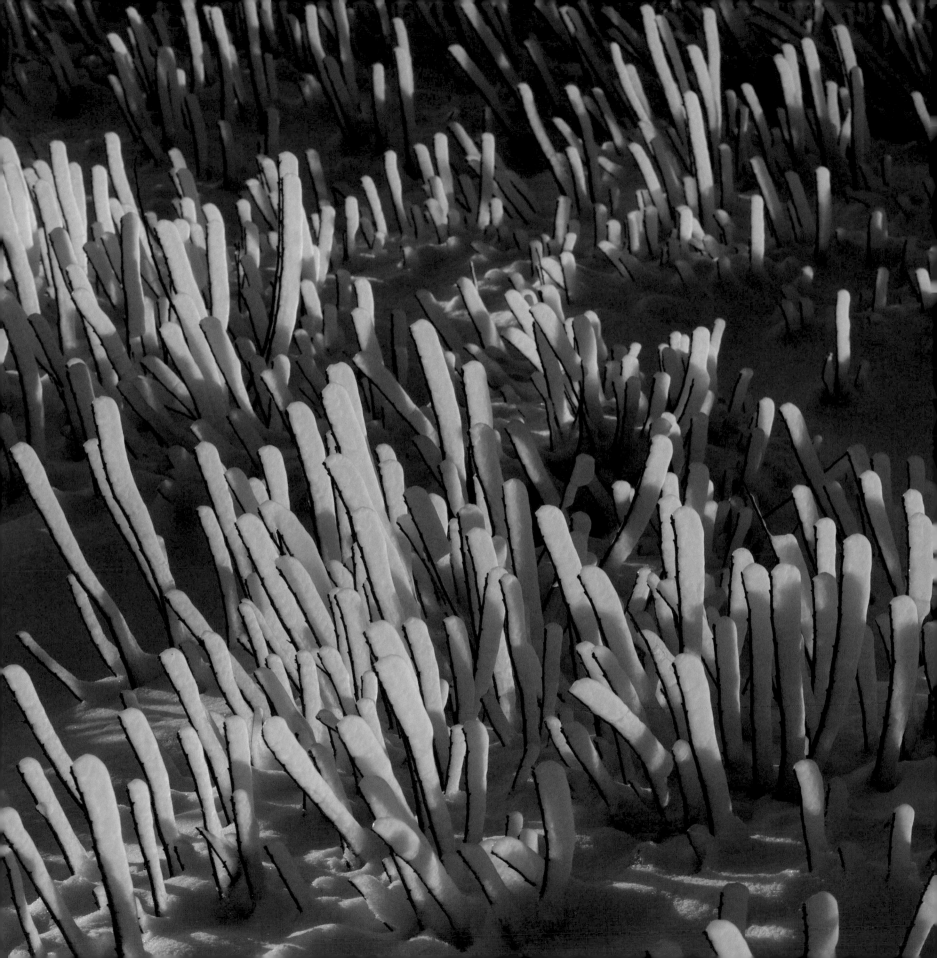

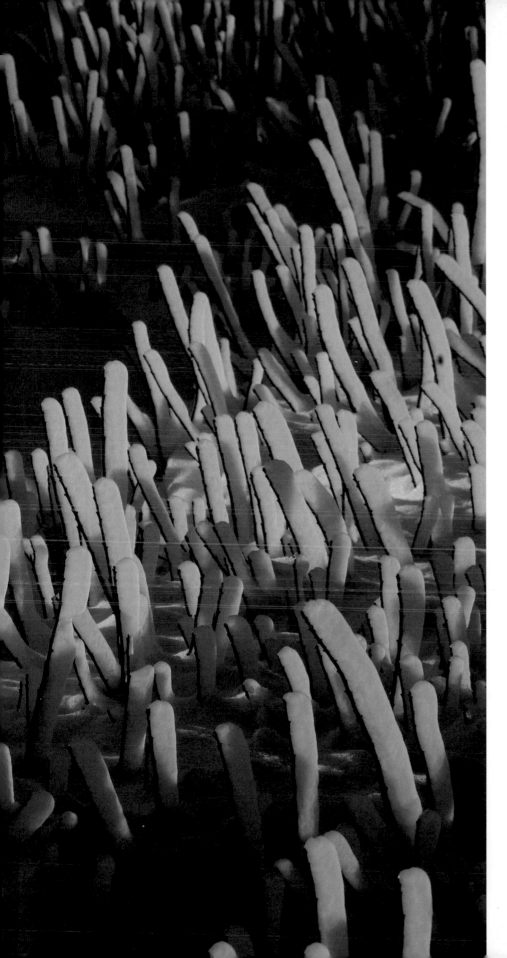

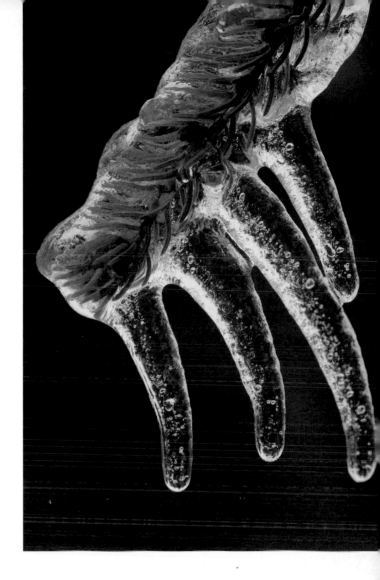

The Island's harsh winter climate produces some unusual and beautiful sights. Two different weather events produced the ice-encrusted vegetation in these images: saltwater spray from a winter storm encases Bayberry shrubs along a cliff edge, while freezing rain sheathes a spruce branch in a thick layer of ice.

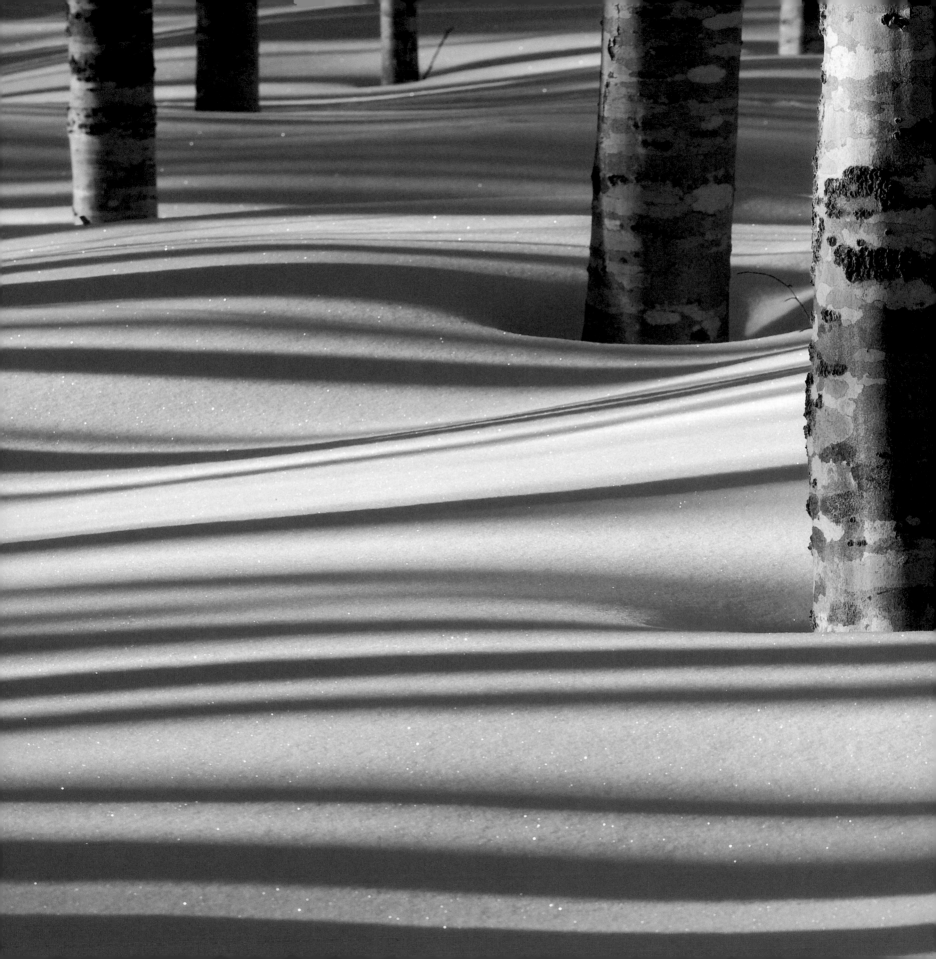

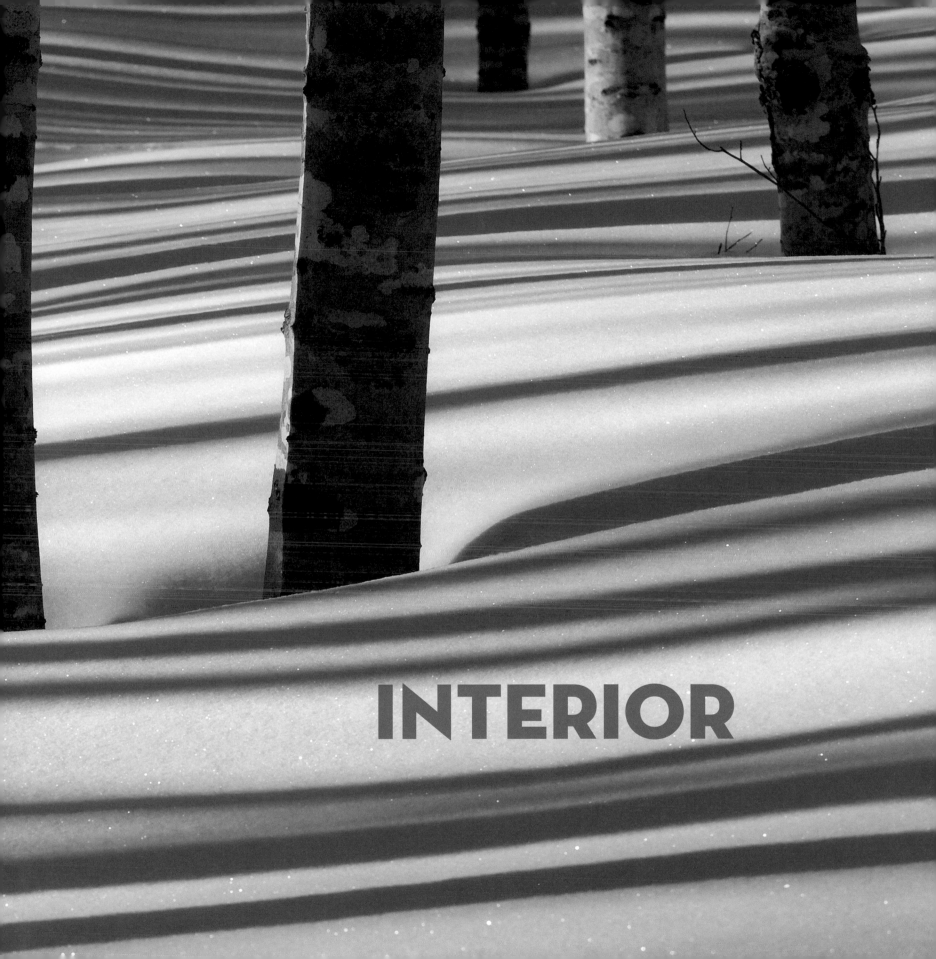

INTERIOR

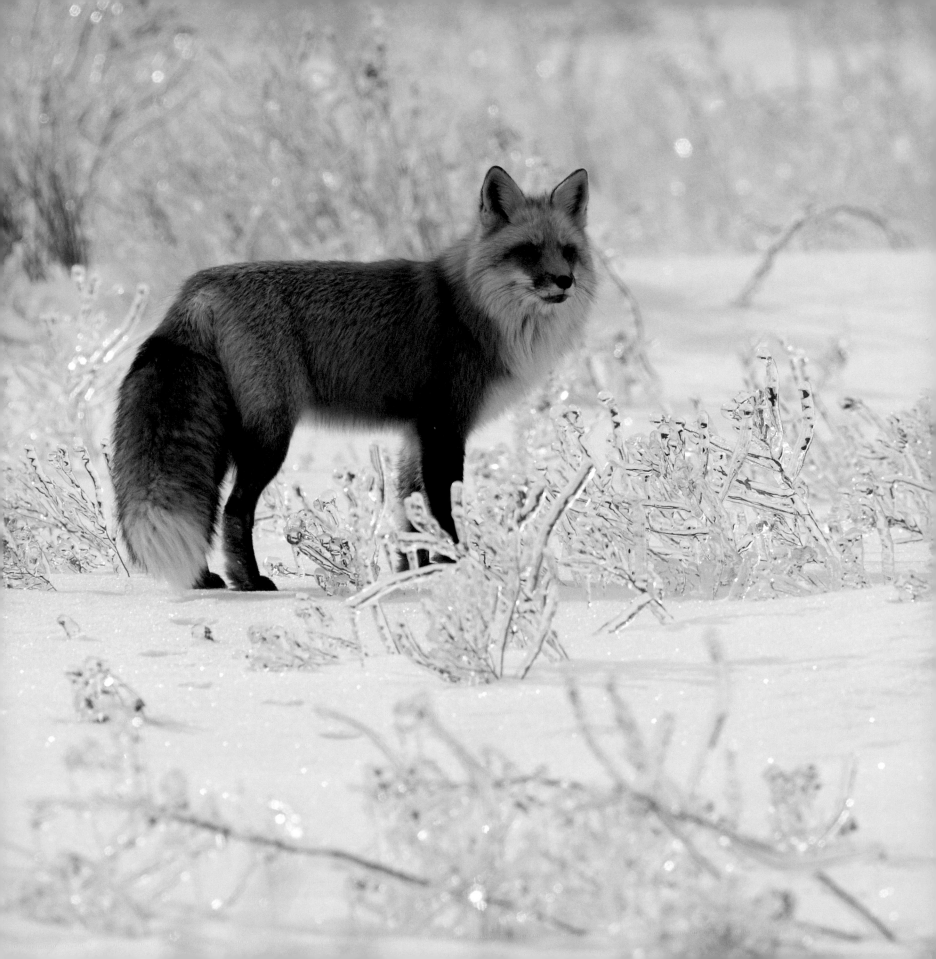

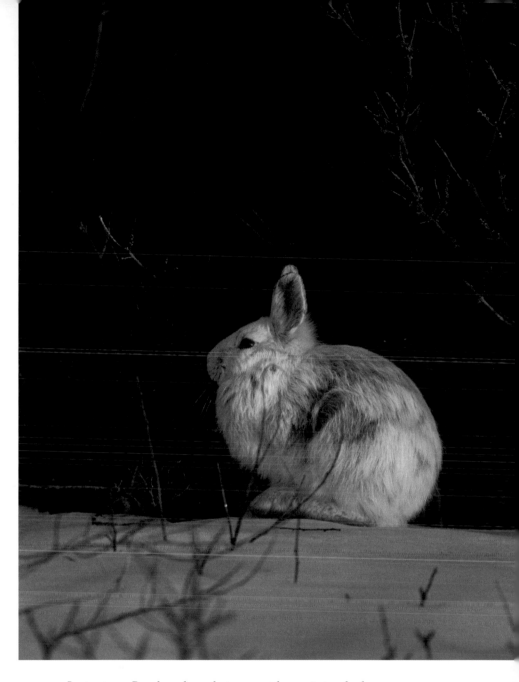

Previous pages: Beech and maple trees cast long winter shadows across the snow in Strathgartney Park.

Red foxes have excellent eyesight. They are capable of spotting the slightest movement — such as the twitch of a hare's ear — when searching for prey.

The aptly named Varying Hare uses camouflage — changing fur colour from brown to white and back again — to protect itself from predators such as the Red Fox. It is also known as the Snowshoe Hare for its large, well-furred hind feet which enable it to move easily over deep snow. Hare populations follow a predictable cycle from scarcity to abundance with numbers peaking every nine to ten years.

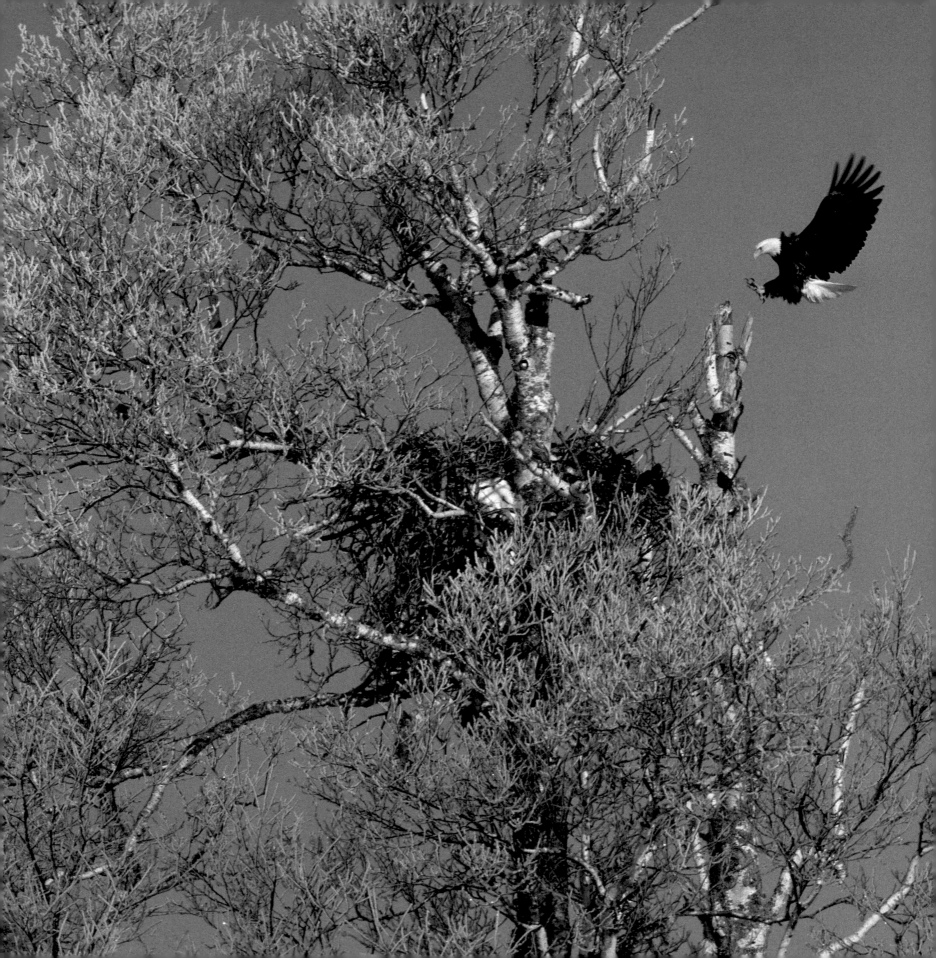

The Bald Eagle population has increased steadily during the past twenty-five years, thanks in part to the education and habitat conservation efforts of the Island Nature Trust and private landowners. In the early 1980s, there was only one known Bald Eagle nest in the province; today there are at least seventy-five nests. Education and habitat conservation efforts by the Island Nature Trust and private landowners have also played a role in increasing numbers.

Bald Eagles are huge birds of prey, with a wing span of over two metres. They feed primarily on fish, but they are opportunists and will also feed on small mammals, birds, and carrion. Their nests are the largest of any bird in North America, measuring up to two metres wide. Eagles nest for life, but, if one dies, the remaining bird will take a new partner. In Prince Edward Island, they begin nesting in late March or early April, usually laying two eggs. The female incubates the eggs for thirty-five days. Once hatched, the female stays with the chicks while the male brings food to the nest. The parents share the feeding duties after six or seven weeks. The young fledge the nest at about sixteen to eighteen weeks, but will be up to five years old before they take a mate of their own.

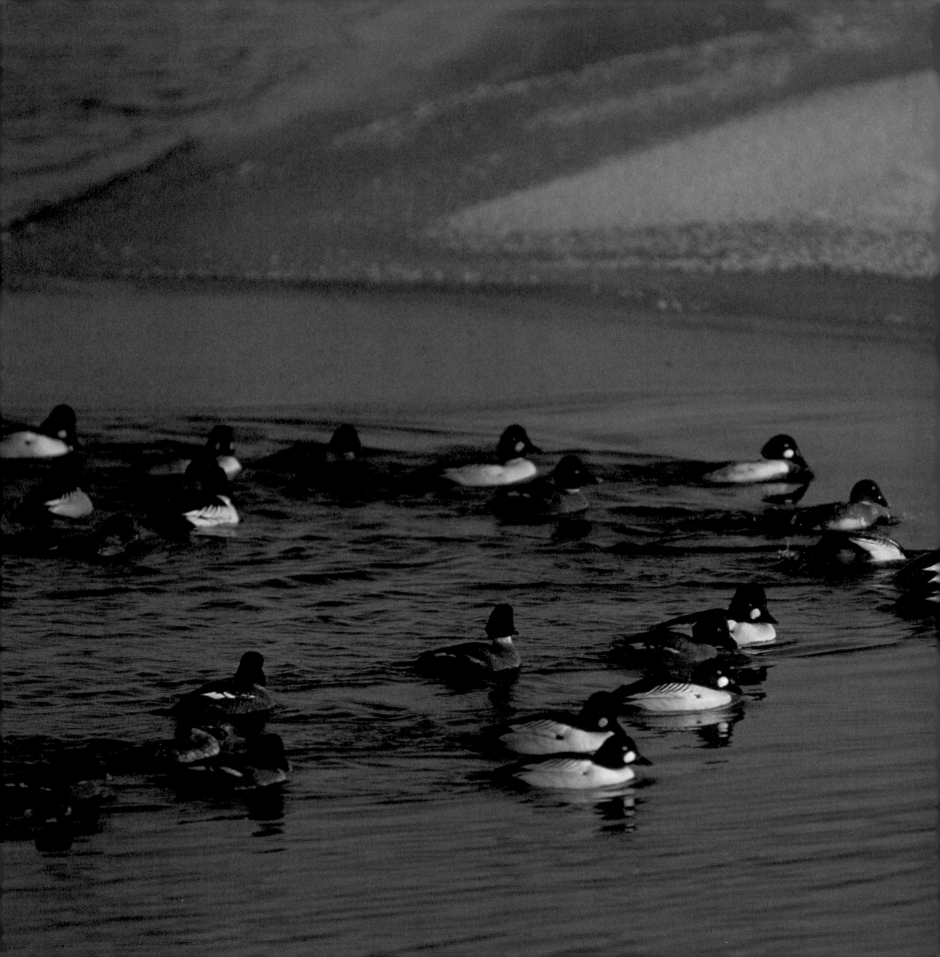

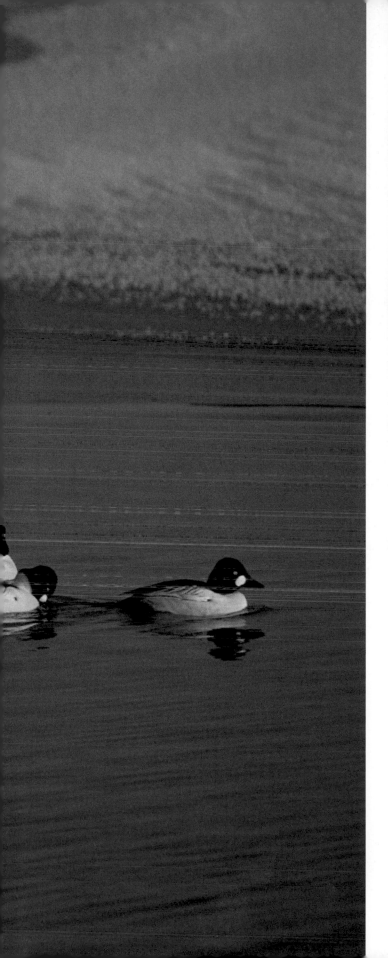

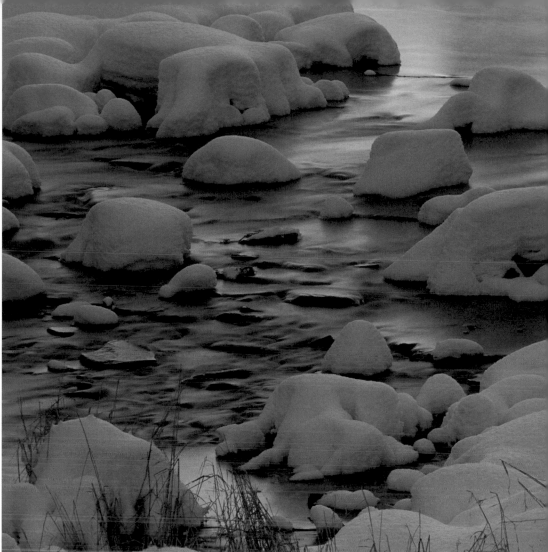

Common Goldeneye ducks are frequent winter visitors to the Island, congregating in small flocks wherever there is open water along the coast, or in rivers, near bridges and causeways where fast-running water prevents ice formation. The Goldeneye is a diving duck with a varied diet of fish, eels, shellfish, insects, and aquatic vegetation.

A blanket of new snow covers a rocky stream in central Prince Edward Island. Most Island rivers are spring-fed at their source, but for most of their length they are primarily tidal inlets or estuaries.

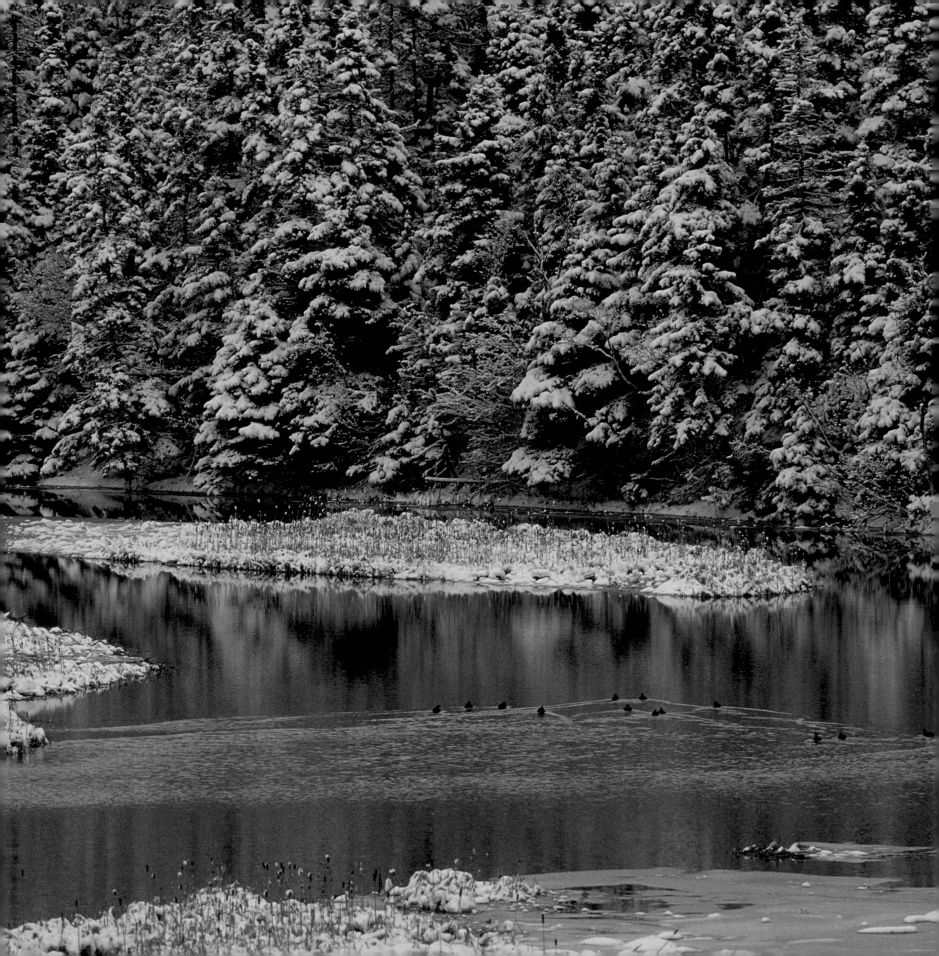

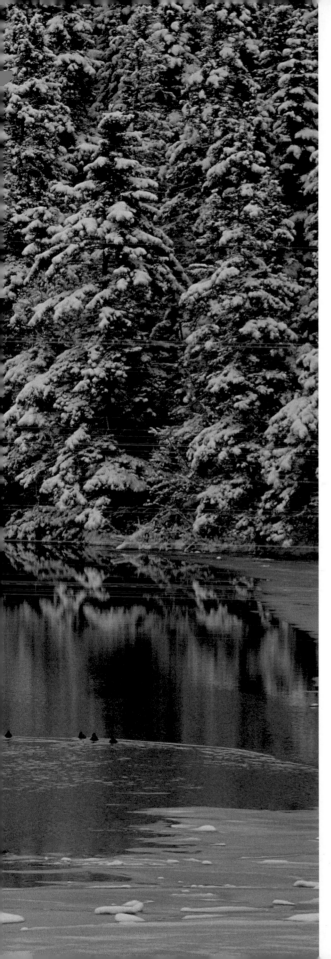

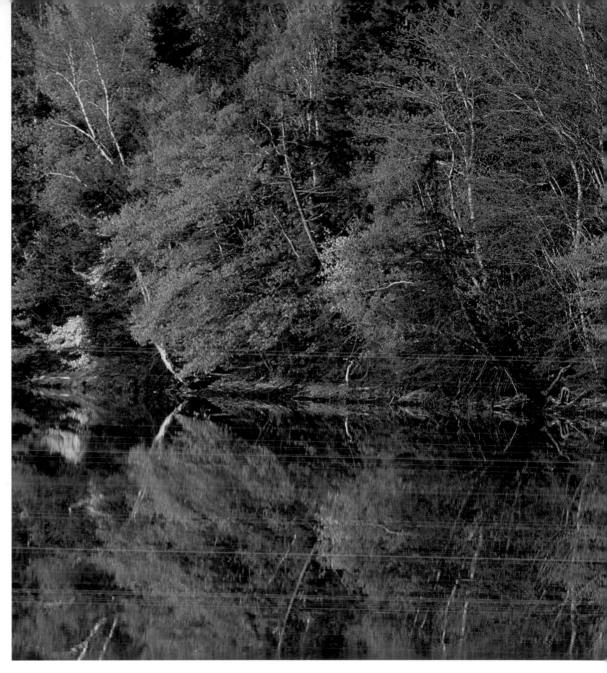

A group of Black Ducks find refuge on the Clyde River, in New Glasgow, after an early winter snowfall. Black Ducks are known as "dabbling ducks," or surface feeders, tipping their heads into the water to pull up aquatic vegetation. They return to the same marsh every fall, sometimes starving to death when the surface freezes over, rather than migrating further south to find open water.

The colours of spring reflect in the surface of the Trout River.

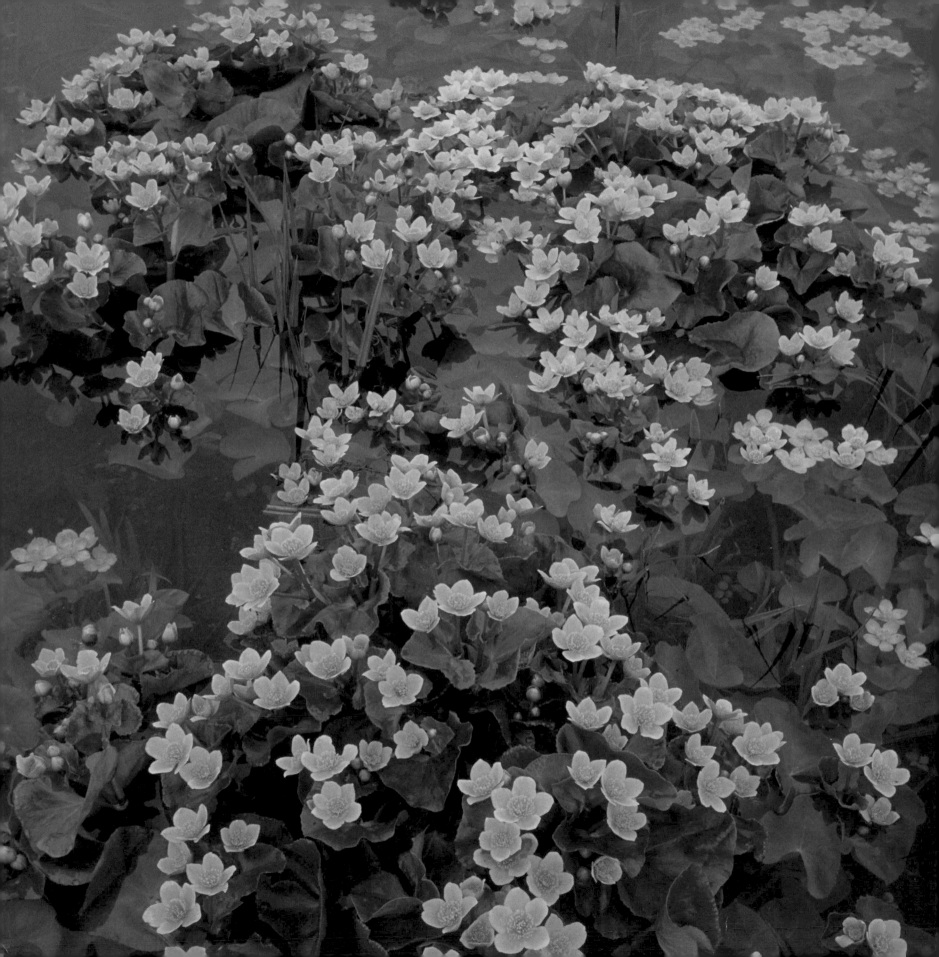

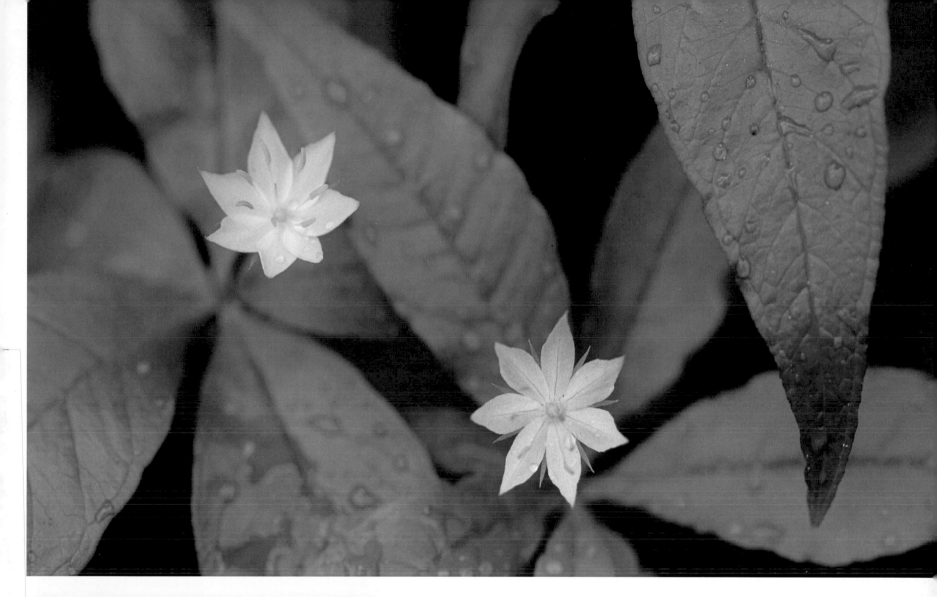

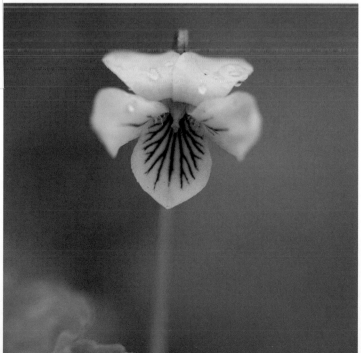

Marsh Marigolds blossom in profusion along the edges of rivers, streams, and marshes throughout the Island in late May and early June. This semi-aquatic member of the Buttercup Family is also called Cowslip or Kings Cup. It contains an alkaloid poison. The greens are edible, but must be thoroughly cooked to destroy the toxic alkaloid.

The Small White Violet (*left*) and the delicate Starflower (*above*) appear on the forest floor in early May.

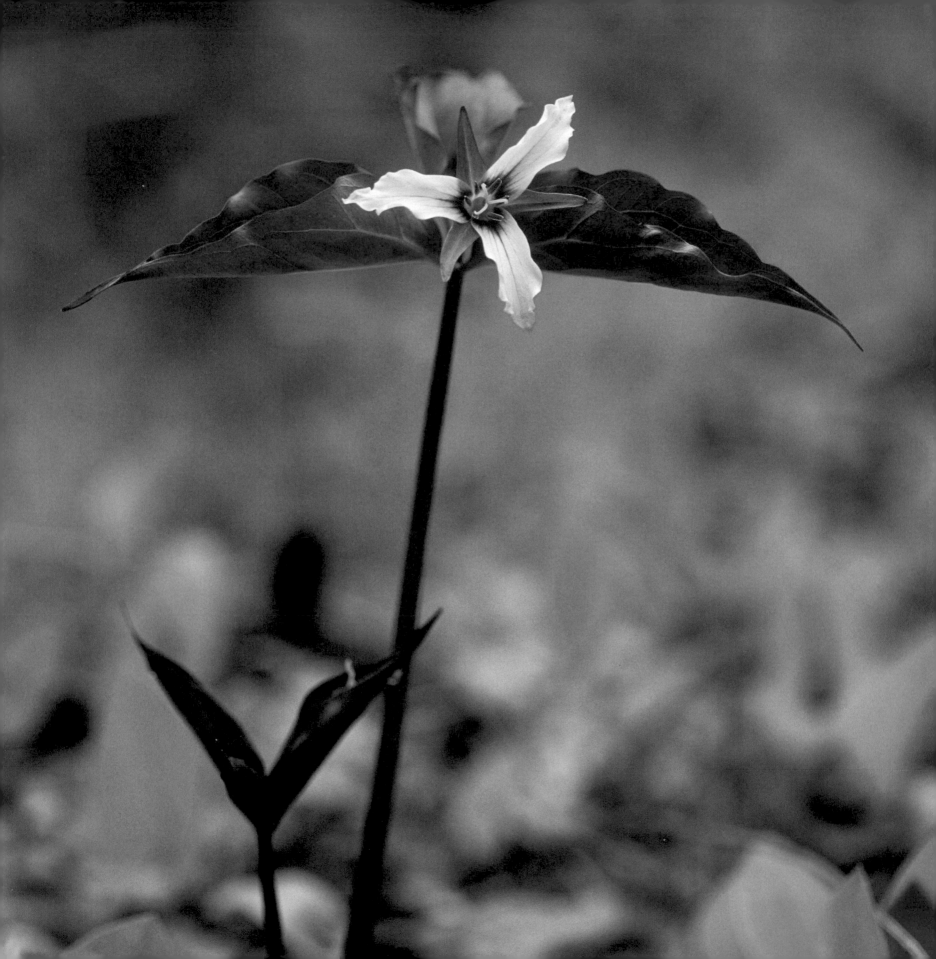

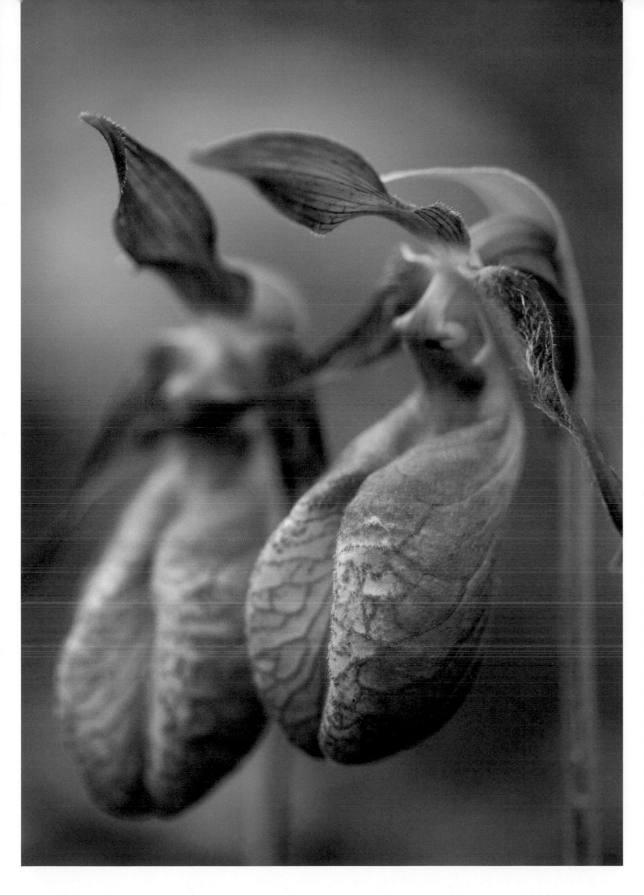

Painted Trilliums flower in mid-June, pushing up through decaying leaves on the forest floor. It's easily identified by the wine-red splash of colour near the centre of its petals.

The province's floral emblem, the Pink Lady's Slipper, is a member of the orchid family. It blossoms in mid-June in mixed woodlands and bogs. Also called the Moccasin flower, Stemless Lady's Slipper, or Whip-poor-will's Shoe, this remarkable plant can live for up to one hundred years, but flowers in only ten to twenty of those years, producing seeds only two to five times. The seeds may take twelve to fifteen years to produce a flowering plant. So their ability to reproduce is extremely limited. They are also highly specialized for pollination by bees. Attracted by the colour and scent of the flower, a bee will land on the "slipper," then, lured by the promise of nectar inside, squeeze through the folded petals into the interior of the flower. Trapped inside, the bee's only way out is to walk along the hairy centre portion of the flower, brushing against the female and male parts, called the stigma and anthers — ensuring pollination of the plant — before finally making an exit to freedom.

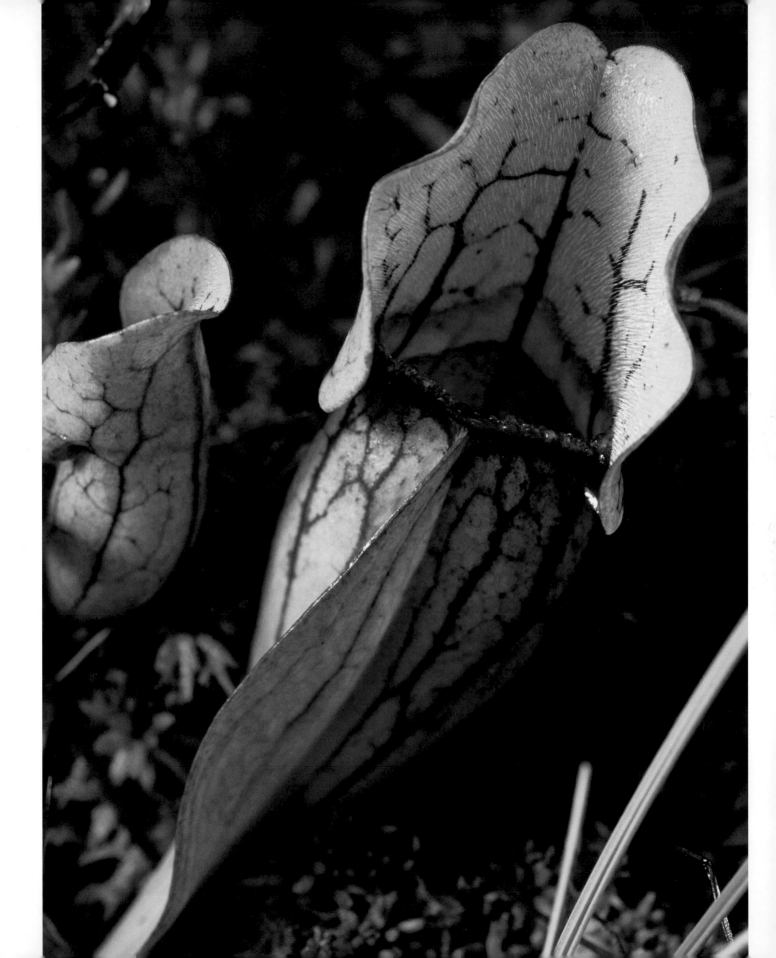

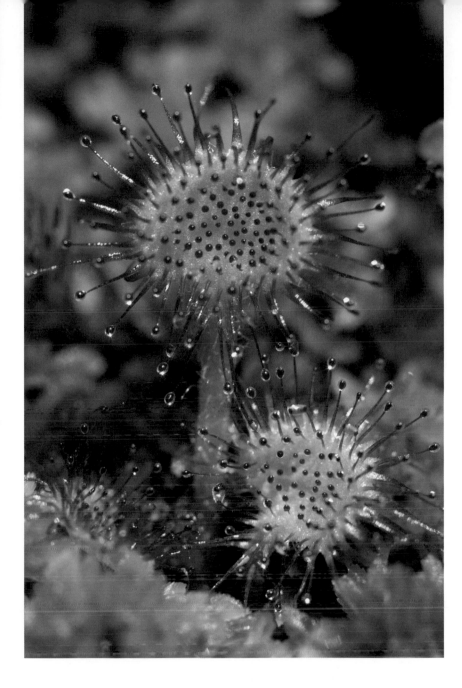

The adverse growing conditions of a bog — acidic soil, low nutrient levels, and low oxygen levels — force some plants to adapt in unusual ways. The distinctive vase shaped leaves of the Pitcher Plant catch rainwater and insects. Brightly coloured veins and nectar glands at the lip of the "vase" attract insects, while the downward pointing hairs direct them into the water reservoir at the base of the "vase," where they inevitably drown. Attempts at escape are thwarted by the downward pointing hairs. It was once thought that insects were digested in a mixture of water and digestive juices produced by the plant. Instead, insects that are specially adapted to live within the Pitcher Plant feed on the drowned insects. Their waste materials are further broken down by micoorganisms in the water, releasing nutrients to the plant.

The tiny carnivorous Round Leafed Sundew captures its meals by attracting insects to the sticky-tipped hairs on its leaves. Once trapped, the leaf closes around the insect for digestion by the plant. A few days later, the leaf will reopen.

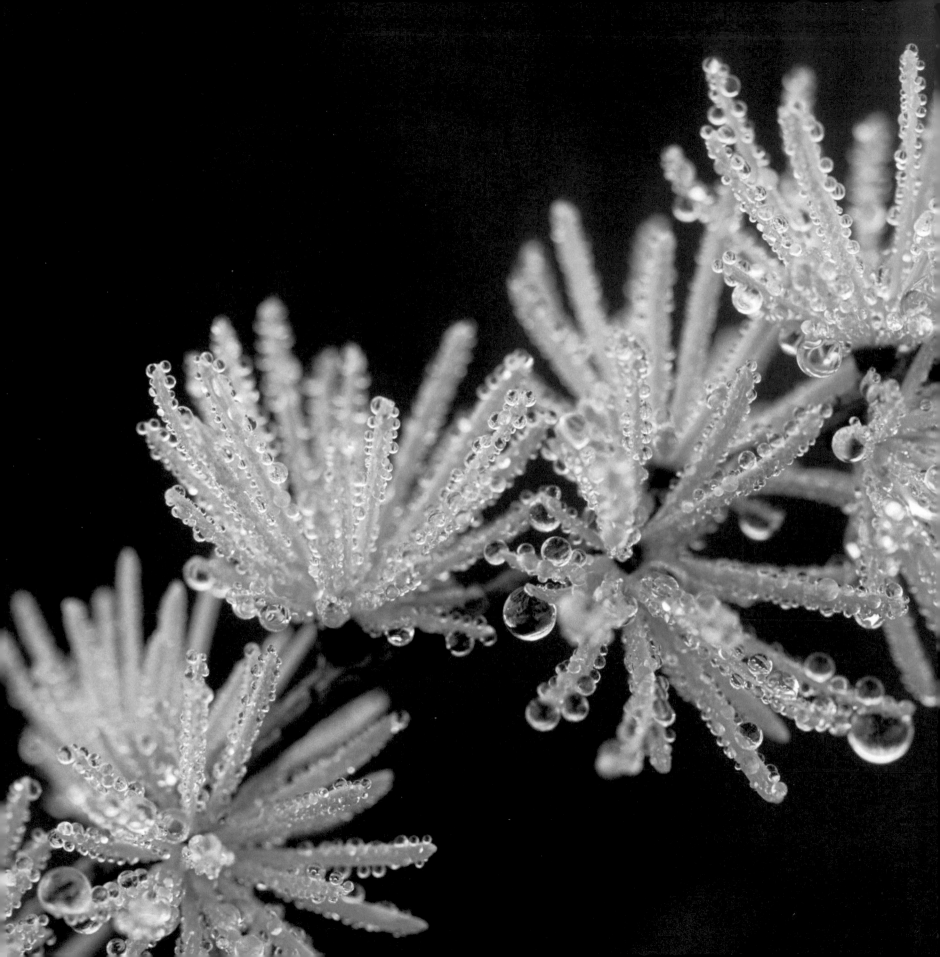

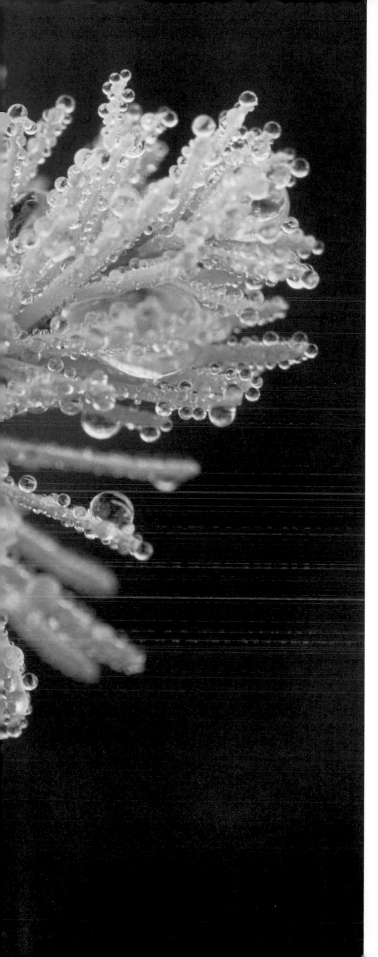

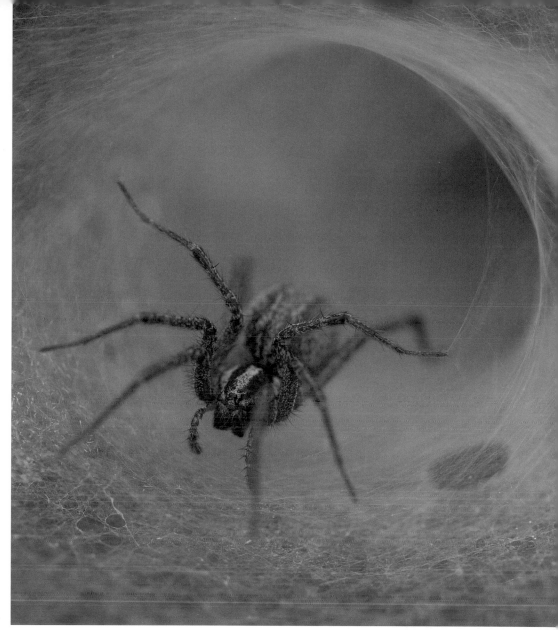

Dewdrops bejewel an eastern larch tree in MacKinnon's Bog. As a bog evolves from open water to forest — called bog succession — it slowly fills in with vegetation. Larch trees are one of the first tree species to appear as the bog approaches its final stage of succession.

Bog resident, the Funnel Web Spider, employs a unique method for capturing prey. Instead of snaring insects in a sticky web, it builds a densely woven funnel-shaped web near the ground and waits patiently, hidden at the base of the funnel. When an insect lands, it becomes momentarily tangled in the dense webbing, sending vibrations through the web to alert the spider. It then darts from its hiding place to pounce on its prey.

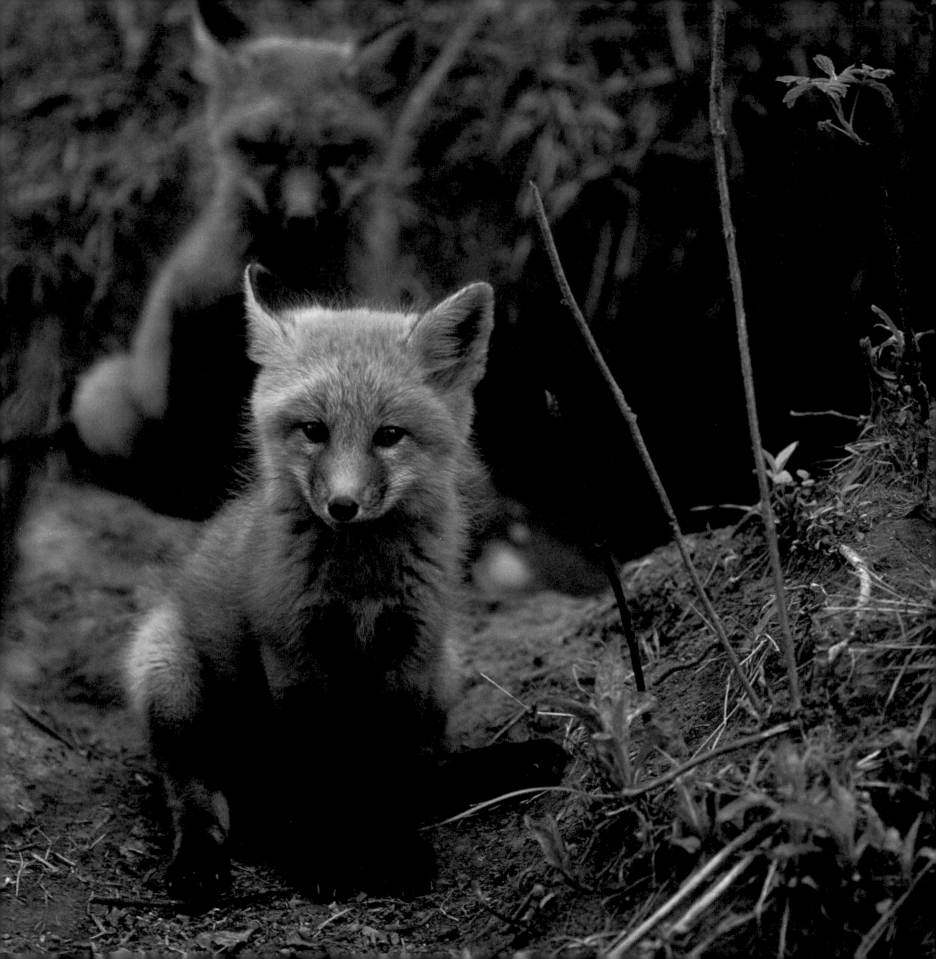

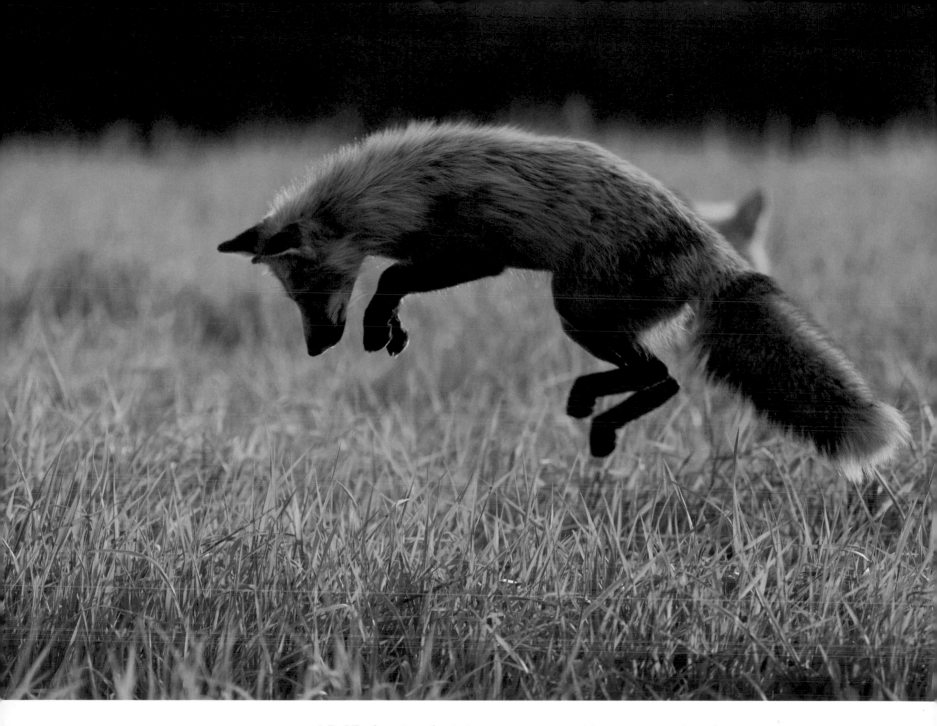

A Red Fox leaps into the air in an attempt at surprising an unsuspecting vole or field mouse. With excellent eyesight, acute hearing, and a keen sense of smell, foxes are well-equipped to find small prey in tall grasses or under snow. Highly adaptable, foxes make their dens in woodland areas, in roadside embankments, under barns, in dunes, and on cliff edges near colonial nesting birds such as cormorants, where they prey on eggs and young birds. Foxes breed in late winter, and the pups, or kits, are born in April and May, usually in litters of four to six. They are weaned at a month and begin to venture outside the den for the first time. Both parents hunt for the kits, bringing back food for them to play with, so that they might begin to learn to hunt for themselves. At about three months the kits will leave the den to hunt on their own.

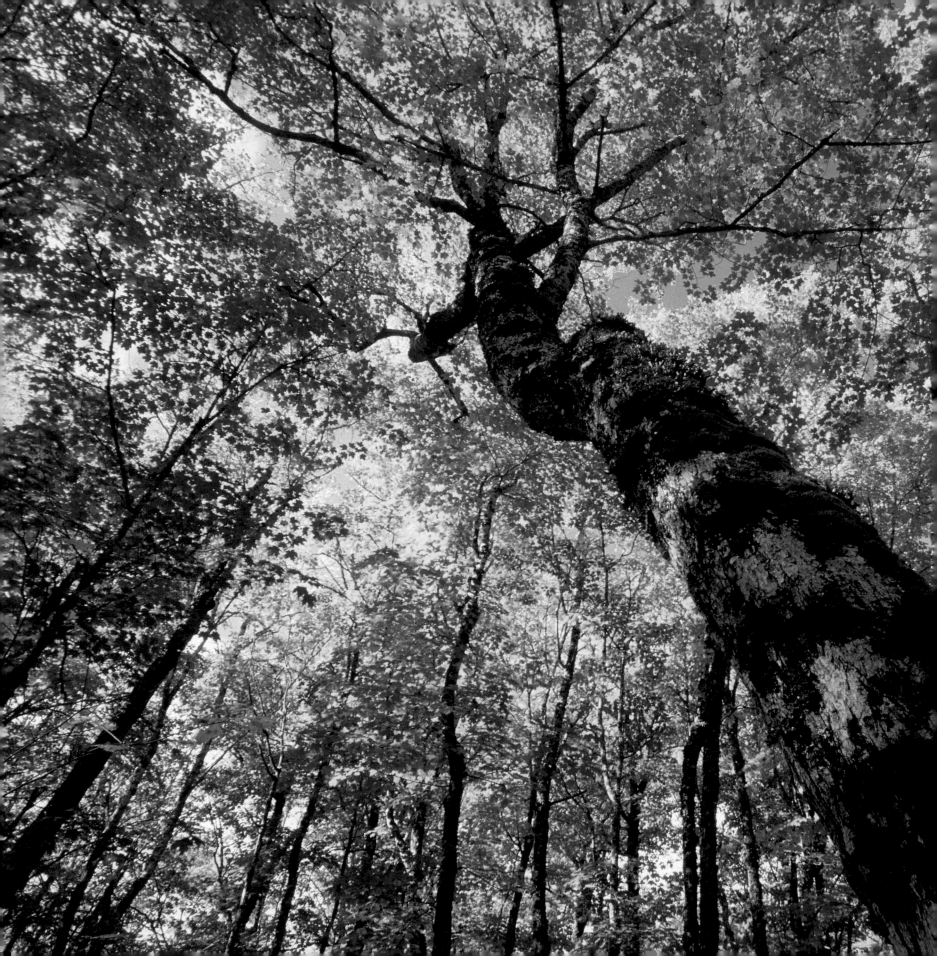

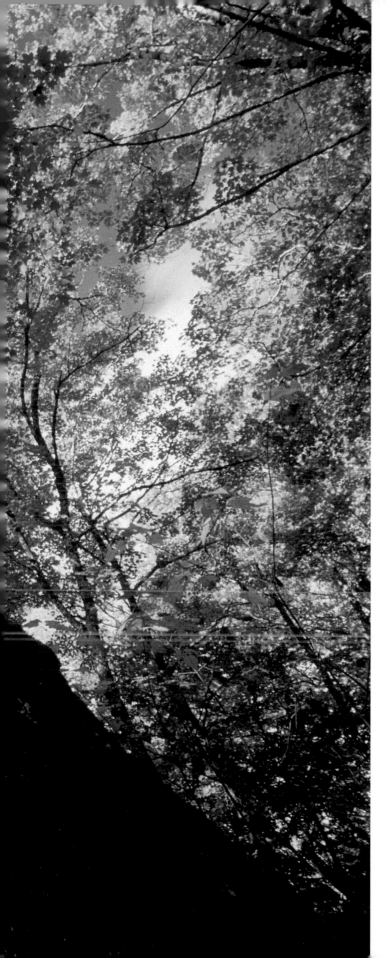

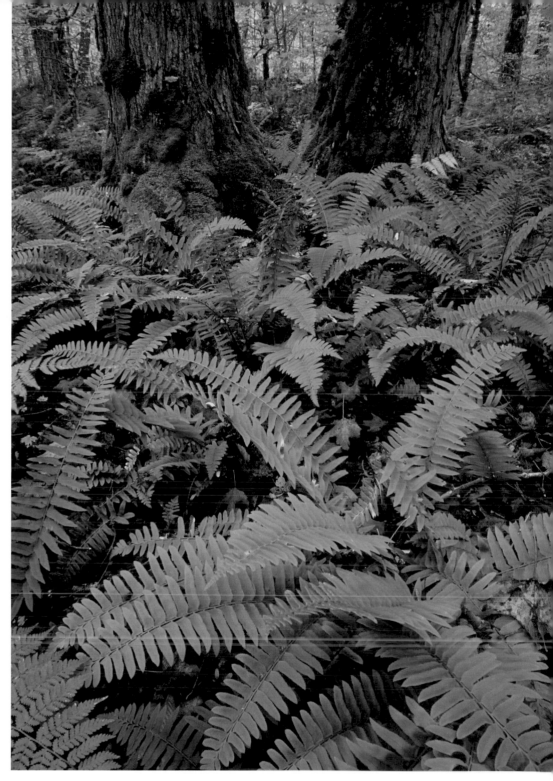

The Townshend Woodlot, in eastern Prince Edward Island, is one of the best hardwood groves in the province. Its towering maple and beech trees — some as old as one hundred and fifty years — are a reminder of the Acadian Forest that once covered all of Prince Edward Island.

Christmas ferns flourish on the forest floor of the Townshend Woodlot. These ferns stay green all winter and were once used for Christmas decorations, hence its name.

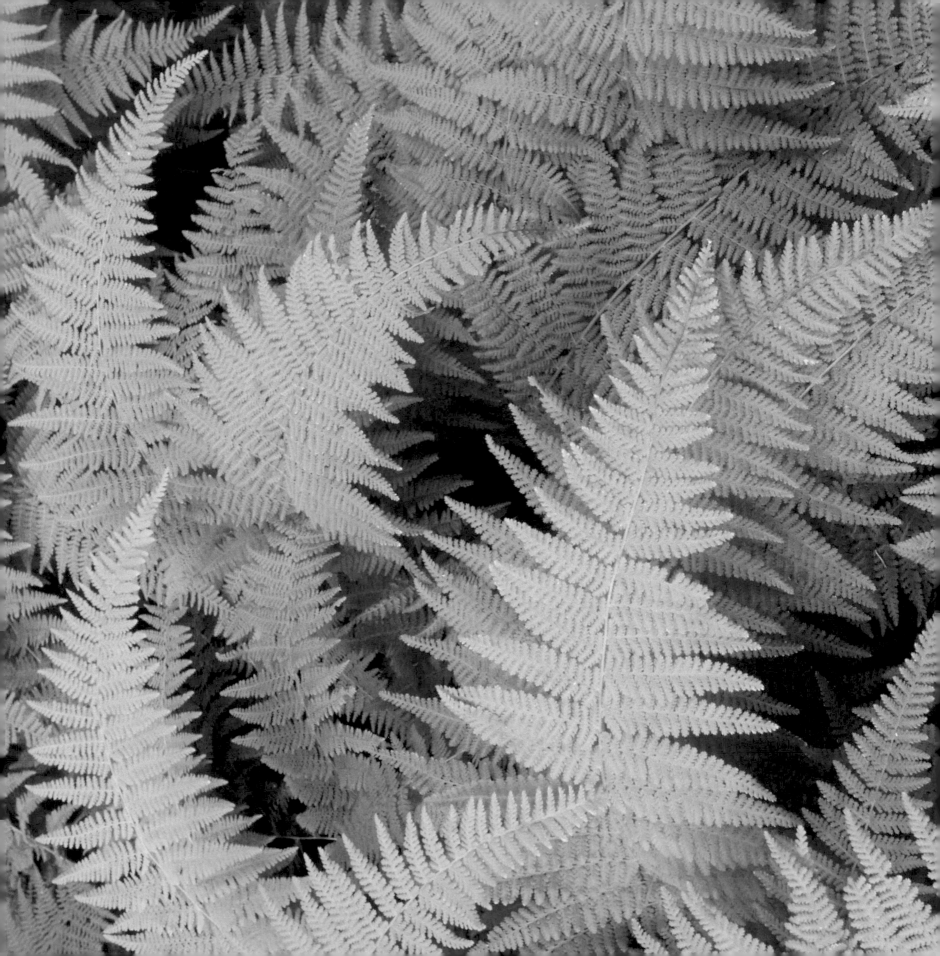

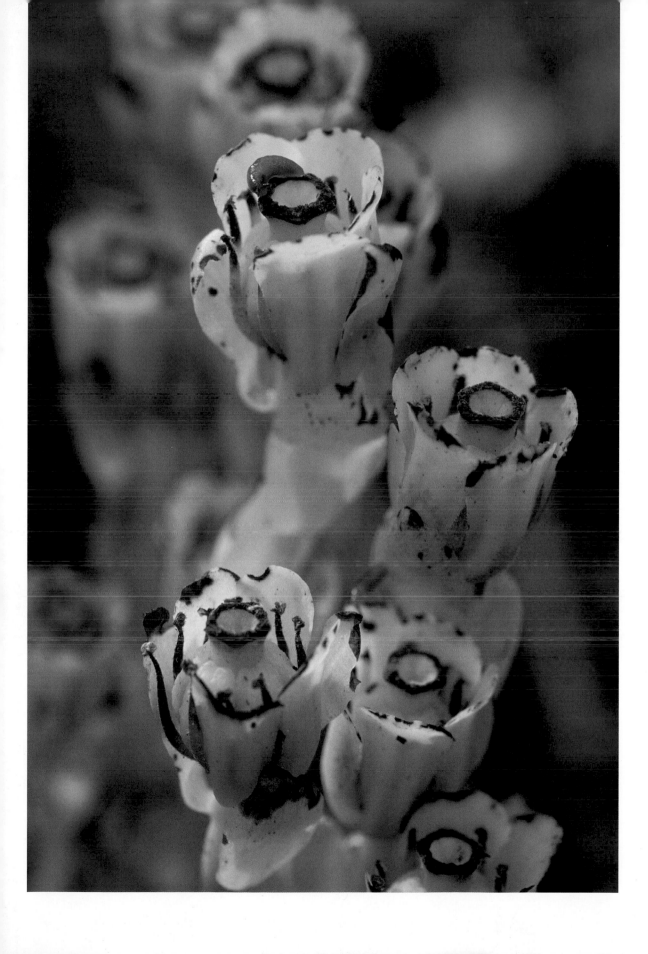

The common Lady fern thrives
in the shady understory of the
Island's spruce forests.

Indian Pipe is a fairly common
woodland plant appearing in clusters
in deep shade on the forest floor
during July and August. Its waxy
white appearance reveals its identity
as a saprophyte, which means it lacks
chlorophyl, the green compound
common to most plants that derive their
nourishment through photosynthesis.
Although it is a plant and not a fungus,
the Indian Pipe gets its nutrients
through a symbiotic relationship with a
fungus in the soil. As the plant ages, it
begins to blacken until the entire plant
is completely blackish-brown and seed
pods form.

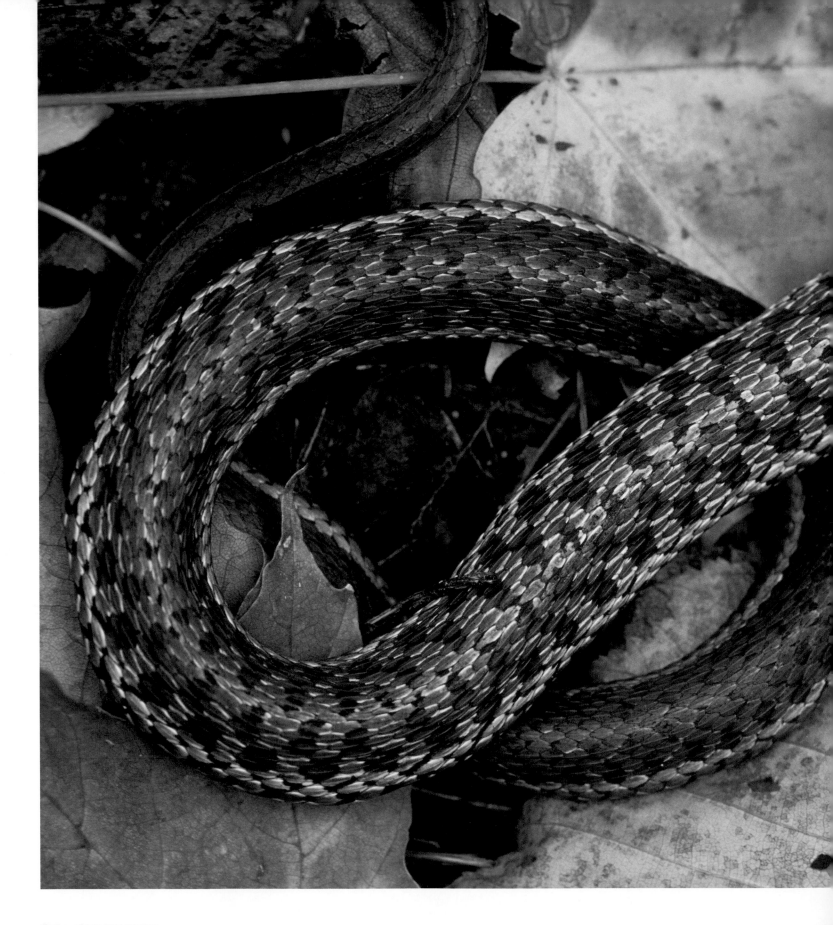

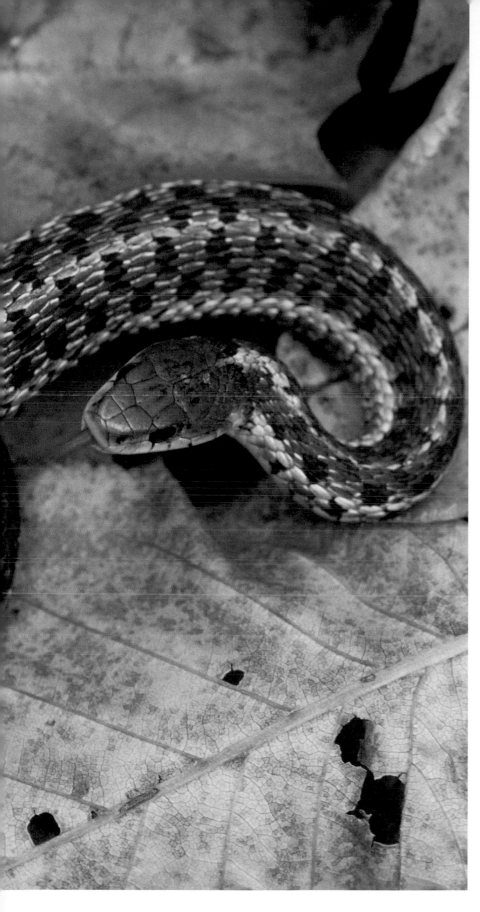

The sugar maple was a common hardwood species in the Acadian forest that covered almost all of Prince Edward Island three hundred years ago. Large specimens, such as this one in Strathgartney Park, are rare today.

The Eastern Garter snake is one of only three snakes found on Prince Edward Island. The other two species are the Red Bellied snake and the Smooth Green snake. None of them is poisonous. The garter snake gets its name from the striped pattern on its back which apparently resembles the pattern on garters once used to hold up men's socks. The pattern is extremely variable, ranging from a solid black with three yellow stripes to a very distinctive checkerboard. They have a diverse diet of frogs, earthworms, slugs, insects, and even carrion. Garter snakes are one of the few snake species that give birth to live young, rather than laying eggs, as do most snakes. Up to fifty five-inch-long young are born at a time. Adults can be found in fields or woodland areas where there is partial cover from vegetation or leaves.

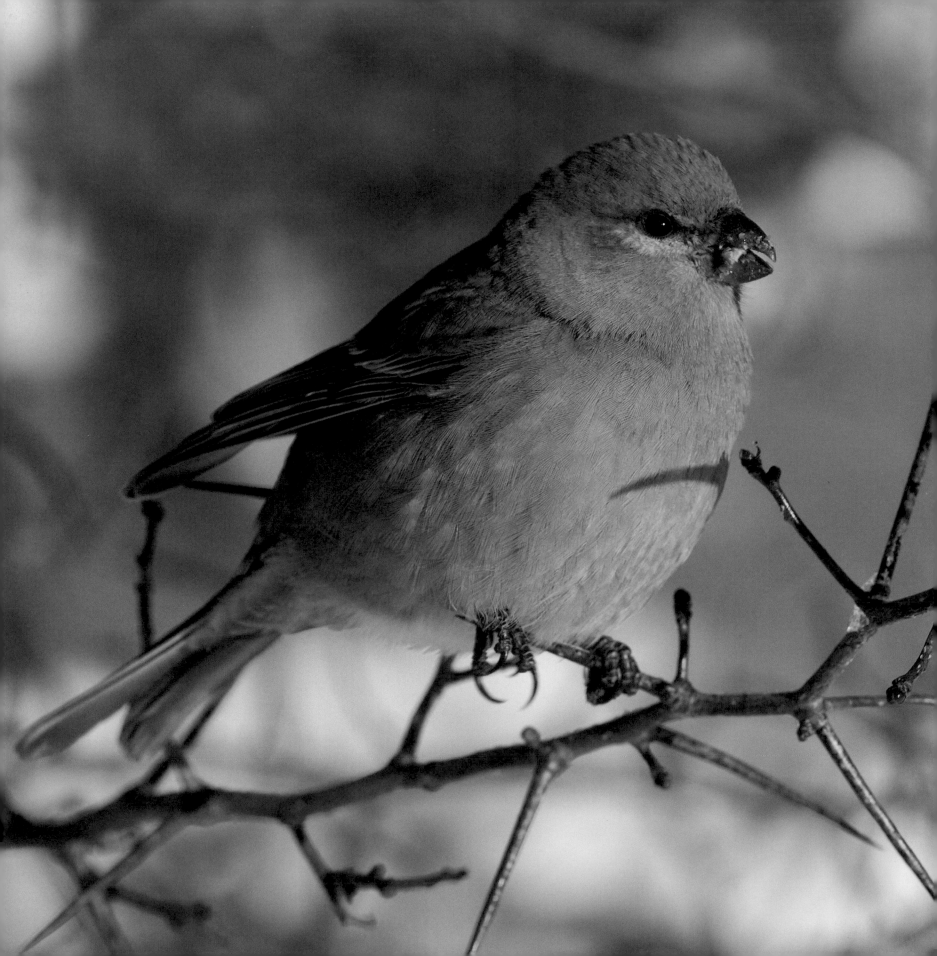

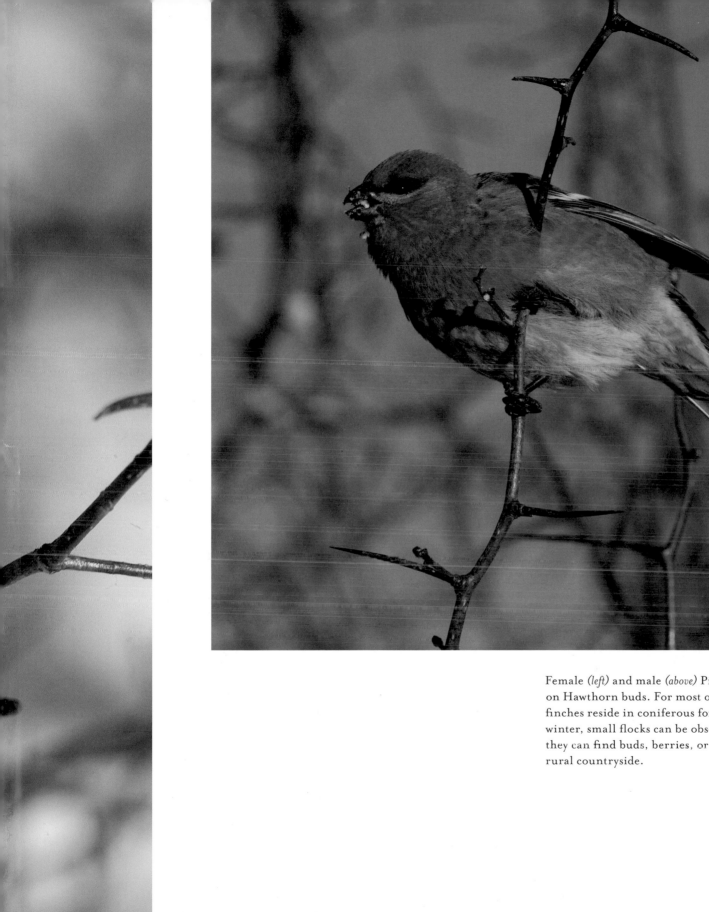

Female *(left)* and male *(above)* Pine Grosbeaks feed on Hawthorn buds. For most of the year, these large finches reside in coniferous forests. However, in winter, small flocks can be observed feeding wherever they can find buds, berries, or seeds in the Island's rural countryside.

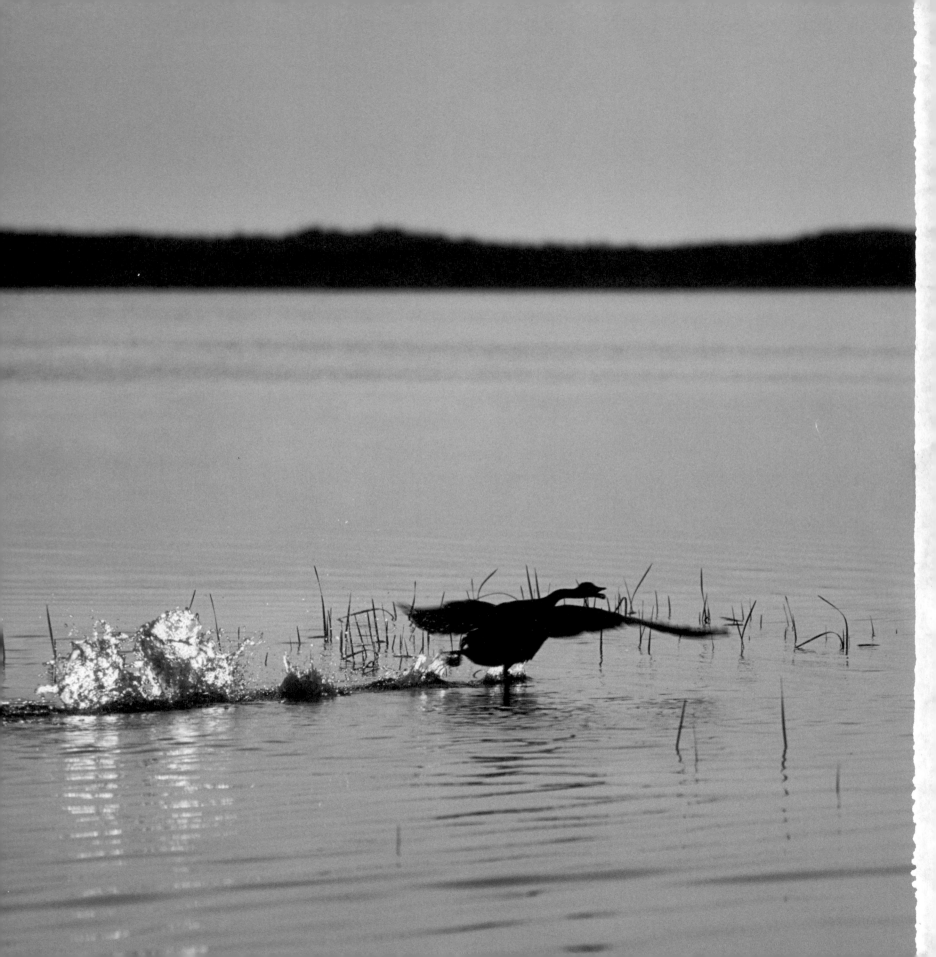